fearless
color
gardens

fearless color gardens

the creative gardener's guide to jumping off the color wheel

keeyla meadows

foreword by
ketzel levine

TIMBER
PRESS

PORTLAND
LONDON

Frontispiece: Blue hand from mermaid patio
Right: *Ranunculus* 'Tecolote Café'
Page 6: Bronze dress

All photographs are by the author except on page 24
by Randi Herman.

Published in 2009 by Timber Press, Inc.

The Haseltine Building
133 S.W. Second Avenue, Suite 450
Portland, Oregon 97204-3527
www.timberpress.com

2 The Quadrant
135 Salusbury Road
London NW6 6RJ
www.timberpress.co.uk

ISBN-13: 978-0-88192-940-9

Printed in China by Global PSD

Library of Congress Cataloging-in-Publication Data

Meadows, Keeyla.
 Fearless color gardens : the creative gardener's guide to jumping off the color wheel / Keeyla Meadows.
 p. cm.
 Includes bibliographical references and index.
 ISBN 978-0-88192-940-9
1. Color in gardening. 2. Plants, Ornamental--Color. I. Title.
 SB454.3.C64M43 2009
 635.9'68--dc22
 2009019449

A catalog record for this book is also available from the British Library

This book is first dedicated to my mother, Estelle Howard,

who shared with me her lifelong passions

of gardening, reading children's stories aloud, and visiting museums,

and her love of art, her joie de vivre,

and her total commitment to her favorite color, yellow.

Yellow mirrored Mom's enthusiasm for life

and her joy in the arts that celebrate the gifts of humanity,

especially as inspired by nature.

This book is further dedicated to all you garden enthusiasts

and to a gardener's earnest sense of eagerness and love of plants.

Also to my grandparents, Dad, Alvin Howard,

my "n-yumm n-yumm n-yumm" Uncle Art,

and my two faithful orange cats, Bix and Jelly.

CONTENTS

Blue callas

I drink purple in the morning and read on lime green. I sleep in smoky blues beneath burnt orange, and I eat in a yellow afterglow. My home is filled with the conversations of color: apricot and aqua for vivacity, ebony and ivory for song. Everywhere I look I see dynamism and expression; every room is an invitation, a dare.

Then I step outside into the calming of green. And green. And more green. The conversation is, to put it nicely, subdued. I suddenly notice that my oasis of a garden breathes in a rhythm I've known since childhood. It's the sound of a sleeping boxer or a tag team of beagles. My garden is one big snore.

Taken as individuals, my plants are gorgeous. Healthy, robust, and flexing with pride. They're also unusual because odd plants are my passion, the undersides of their leaves iridescent and their bark like rebar, camouflage, or cork. People ask a whole lot of questions in my garden: What's this? Where'd you find that? How do you spell the species name? But they don't gasp or laugh or spin like children, and now I know why.

My garden lacks color, and color is fun.

Enter the impulsive, indulgent, irresistible Keeyla Meadows with her overstuffed Santa sack of ideas for teaching design-impaired plant lovers like myself how to work with color. She's hardly the first to try, but she's among the few I care to follow, turning much of it into a few simple steps called "the hokey-pokey color dance."

I kid you not.

Choose a flower, any color. Then put a slightly warmer flower color to its left, and a slightly cooler flower color to its right. Now turn yourself around and behold a relationship. A conversation that makes sense. What you've created is a color palette, and that's what it's all about.

Do not scoff! Many of us turn color in the garden into mud because we don't get what's wrong. Consider the bane of my summer garden, a handful of 'Casa Blanca' lilies. By all rights, their swooning smell and bright faces should add rather than subtract from the garden. Instead, they just screw things up. Why, Keeyla, why?

"White can stick out like a flag of surrender," writes our author. (I think, Yes! I surrender! I don't know how to use color!) In no time she's delivered me to safer shores. Turns out I'd placed my lilies in such a way as to defile even the sweetest fragrance. I'd created color's greatest nemesis, what Keeyla calls "the loathsome blotch."

A small breakthrough, a step forward, and an exuberant friend beside me as I learn to bring my love of color out of the house and into the garden. I drink purple, I read on lime green, and soon enough, I will spin among the colors in my oasis of green.

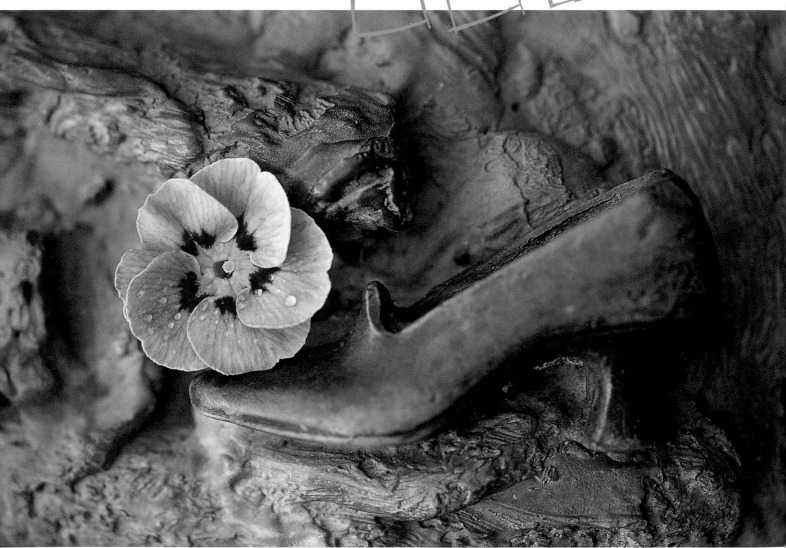

Bronze shoe with primrose

ACKNOWLEDGMENTS ✳

As with creating a garden, making a book is a collaborative process, and there are many people I'd like to acknowledge and extend appreciation to: Tom Fischer and Timber Press for their belief in and support of this project; kindred spirit Lorraine Anderson for making the editing process so much fun; Ann Leyhe, co-owner of Mrs. Dalloway's bookstore, for her longtime friendship that has included such generosity in reading and commenting on this manuscript and on any garden project I conjure up; and Susan Ashley, a teacher of plant propagation and a master painter of color both in her garden and on paper, for her constant inspiration and assistance with image editing.

I'd like to extend my deepest thanks to Jane Jeszeck for her inspired graphic design.

Several people offered support and input in the editing and selection of photos for this book, including Marissa Hutchinson, Nicole Berger, Jean Moshofsky Butler, and Ruth Moon. I offer special thanks to Chanel Kong for all aspects of editing and bringing the raw materials together into a book. Her attention to detail has been invaluable to me.

All of my clients have been a pleasure to work with on their gardens and have been generous in making their gardens available to me to photograph and write about. I extend my warmest appreciation to my landscape crew, including Ronald Menjivar, with special thanks to Julio Escobar, landscape supervisor, who has stuck with the business and details of making gardens works of art for more than fifteen years.

My special thanks go to Lou Trousdale, owner of American Soil & Stone Products; Dale and Carla Smith, owners of Artworks Foundry, for creative support and excellent craftsmanship of all my bronze sculptures; Stan Huncilman for sculpture fabrication; Rod Fitiausi and Jim Fox for ceramics; and to the many wonderful plant growers and nurseries up and down the West Coast, including Annie's Annuals, Berkeley Horticultural Nursery, Emerisa Gardens, Homestead Gardens, San Marcos Growers, and Suncrest Nurseries. I'd like to extend my gratitude to Marshall Olbrich and Lester Hawkins of Western Hills Nursery for their careful handling and intuitive response to my 'cultural' needs as they prepared me for my long and adventurous path as a garden artist.

I'd also like to thank the editors, writers, and photographers at the various magazines that have published articles about my garden, as well as the crew for Grow It! and the San Francisco Flower and Garden Show. All have given me support for making creative gardens.

My additional thanks to Jane Pitts and Steven Herman for business and legal advice; to my neighbors—Deedee and Brett, Rosemary and Marie, Kitty and David—for, among all their other types of support, providing many memorable meals where we discussed gardening and writing while seated around their kitchen tables, and, in addition, for being available for spur-of-the-moment help in photo and text editing.

My garden roots took hold in my family home, and I'd like to thank my mother for imparting her love of the garden, sweet peas, columbine, daffodils, fruits and vegetables, and the color yellow; my father for supplying me with my first camera; and also to my garden mentor, Richard Frazier, for planting seeds of my becoming an artist in the garden.

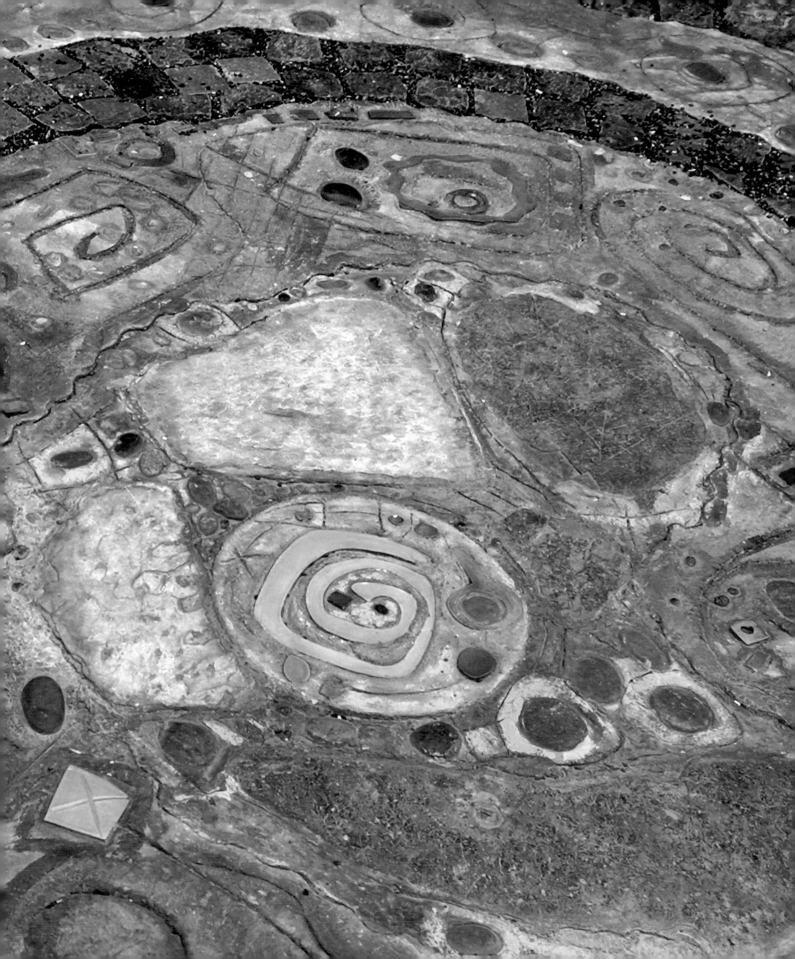

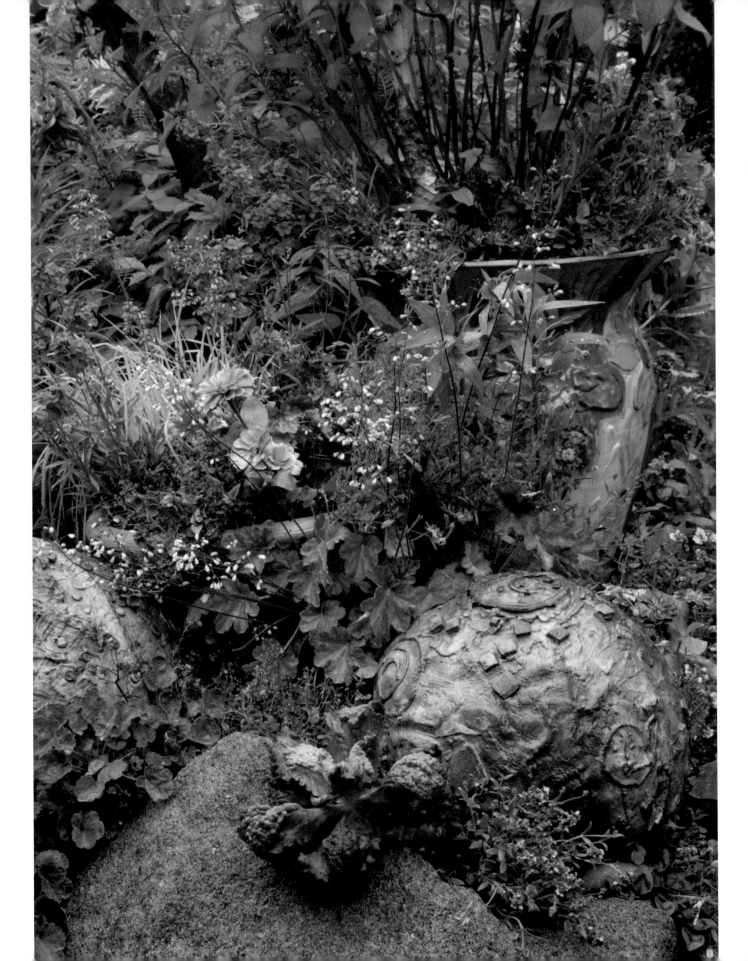

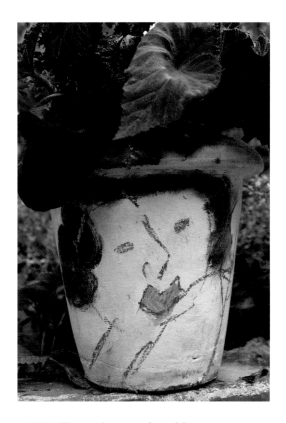

INTRODUCTION
Color Journey

This story starts midday on a summer morning while I was giving a color class in my garden. With one hand holding a pot painted with an image of a woman's face, the other hand about to plant a flowering red begonia to match the painted swatch of red hair framing the face, I noticed a tall woman in the back of the crowd of garden enthusiasts waving her hand for my attention. My eyes traveled from the red begonia and the red painted hair on the pot to the rising flush on the tall woman's cheeks. Afraid that she was about to faint, I turned my full attention to the woman's awkward giddiness.

"Coming into your garden is like having a psychedelic experience. The color is so vibrant it leaps from the flowers. I feel like I'm swimming in color." With a sweep of her hand as if to steady her sense of vertigo, she stammered, "You don't seem to be afraid of color at all." Straightening to her full height, she then demanded a response to her question. "What gave you the nerve to be so bold?"

I scrunched my eyes against the glare of the morning sun as the rest of the gathered gardeners nodded their heads in sympathy with

ABOVE Painted pot with red lettuce and red begonia

LEFT Swimming in a sea of garden color

RIGHT *Ranunculus* 'Tecolote Café'

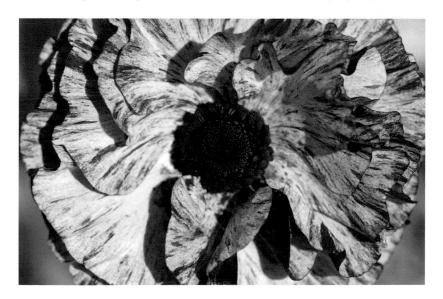

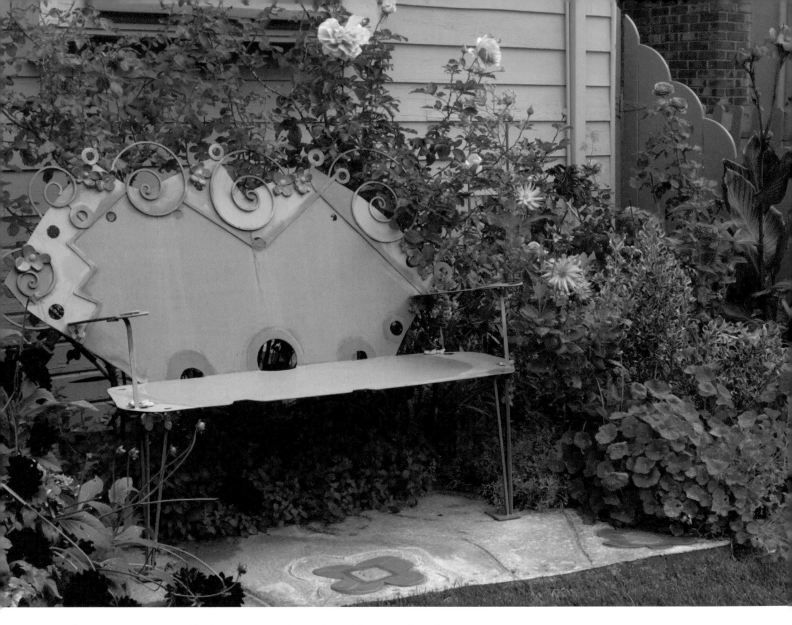

Painted metal bench with matching colors in the garden

the woman's sense of helplessness in the midst of the sea of garden color. Turning my gaze inward, rallying slumbering memories of my first steps on my journey into color, I groped for words to tell the story of my path, hoping it might offer reassurance, keys, tips, and guides into this rainbow land of color that I now take for granted.

Color Is Fun and Color Is Everywhere

People tell me they are afraid of color. My experience of color is that color is fun. So when I decided to write a garden book on color, I wanted to support gardeners when they work with color, to make their experiences both empowering and rewarding.

As your guide on this color journey, I have as many doubts, hesitations, and fears as the next person about many things, but I have

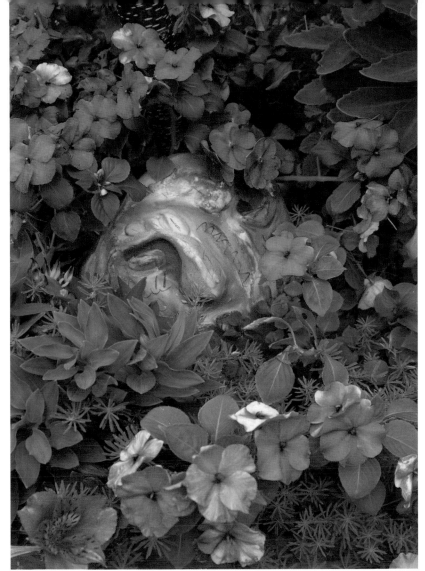

ABOVE Edges of two echeverias
RIGHT Ceramic head with impatiens

only passion, exuberance, certainty, and bravado regarding color. So jump on my bandwagon and get ready for an adventure as we pass under nature's rainbow arch of miracles into a celebration of color in the garden.

On this journey we will tune into the great color potential for creating gardens. Plants are at center stage of garden color. Plants, especially as they come into bloom, fruit, and seed are the source of some of the most beautiful, vibrant, intricate color on earth and in the garden. Aside from plants, everything having to do with the setting where the plants reside can be equally colorful.

In my gardens, color refers to everything—absolutely everything. I don't just make a bland holder, a neutral vase, for colorful plants. Color includes the rocks, the pavings, and the artwork. It also connects up with the color of the house and the sky above. So it's really like bringing the camera to your eye. When you take a photo, you are

looking at everything in the frame. In creating color gardens we will look at everything that is part of the garden "picture." And by the way, I think the camera is as important a garden tool as your trowel, your pruner, and your hoe, because it's really what facilitates your seeing in the garden.

It's the dynamic relationship between the plants and everything else that makes the garden truly alive, talkative, theatrical, nurturing, inviting. You, the gardener, are the one to set this potentially powerful relationship into motion.

Paradise: Start with One Color

I have found many books that talk about putting together color combinations for plants. This is a wonderful and necessary aspect of designing with plants. But the potential for colorful garden design is much larger, broader, and more inclusive. Leaves, petals, bark, and fruit might be your starting point for engaging color in the garden, but there is also everything that is going to surround, contain, and interact with the plants. Every object brought in to accomplish the design is given a color test. Each area of the garden is assigned a definite color palette. The number of colors in an area can be quite broad or quite narrow, just as long as the colors fit the selected palette.

You will learn about putting together color palettes and, perhaps more important, how to design with color. The first part of the book addresses making color combinations. You will explore your color passions. Then, like an artist choosing a color palette by squeezing paint onto her palette board, you will select color palettes for each section of the garden.

The second part of the book focuses on the work of creating color gardens. In this section I share with you the design principles I follow in making strong garden compositions. You will learn to create an outline, a structure for the color, like the lines in children's coloring books.

In the third part of the book we'll take a look at some gardens that have been adventurous in their use of color.

In all of my work as an artist, whether designing or creating a garden, clothes, paintings, ceramics, sculpture, or photography, I follow one simple guideline. People often come up to me and say, "You do so many things, I bet you don't sleep." It's not the lack of sleep that enables me to do a variety of things. It's that the same simple guideline applies to all of them. I start with one thing; that is the key.

I learned to start with one thing from plants. Plants start with one thing. They start from seeds. The seed unfolds. That is how I work with

Sketch for a wild garden path

TRY THIS: Take a Walk and Write a Color Portrait

Take a walk around your garden, then around your neighborhood. Appreciate the potential of the full scene. Look at the whole space as if it were a stage set for a play or the canvas of a painting. Look from edge to edge of the scene. Notice every single color in view, including the colors of the earth and sky. Write and sketch a color portrait of your garden. Update your portrait each month. This will help you keep in touch with the potential for color in your garden at each season. Keep your original portrait to compare with your garden after revamping it with a new eye to color.

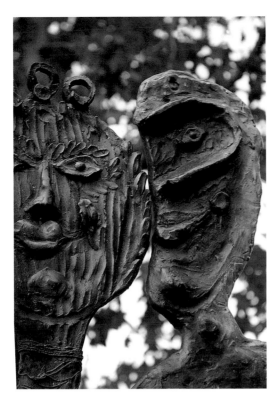

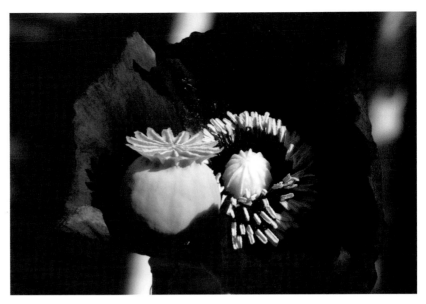

ABOVE Bronze couple

TOP RIGHT Breadseed poppy

BELOW RIGHT Geraniums matching paint

color. I start with a seed color and let the color palette and then the garden unfold from there.

I believe in seeds. I love seeds. I love to hold seeds in my hand, take them out of their dried pods, open the soil, drop them in, water and care for them. I can identify most of the plants in my garden by the first two leaves of their sprouting seeds. This book is full of color seeds for you to journey with. The first principle of this color journey is to make it simple. Start with one thing. Start with one idea. Start with one color. On my color journey, the starting seed color is yellow.

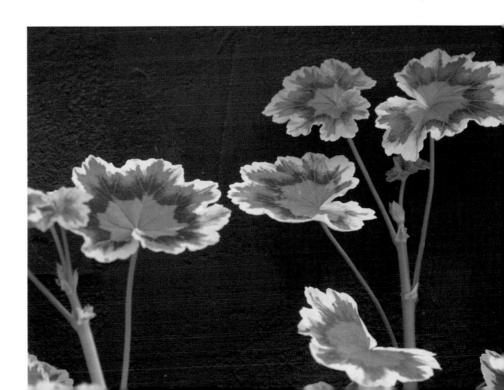

Putting Together Color Palettes

So where did my color journey begin? The color yellow started me on what I call my "follow the yellow brick road" path, over the rainbow into a vast colorland. Only my path is not made of brick but of ordinary garden dirt or a patch of lawn, leading to beds and planters of wildly jazzy, trumpeting-out-the-brightest-sunshine yellow that only daffodils can do.

LEFT Inspired by red-purples and yellow-greens

BELOW Flowers and foliage in a palette of mauves and yellows

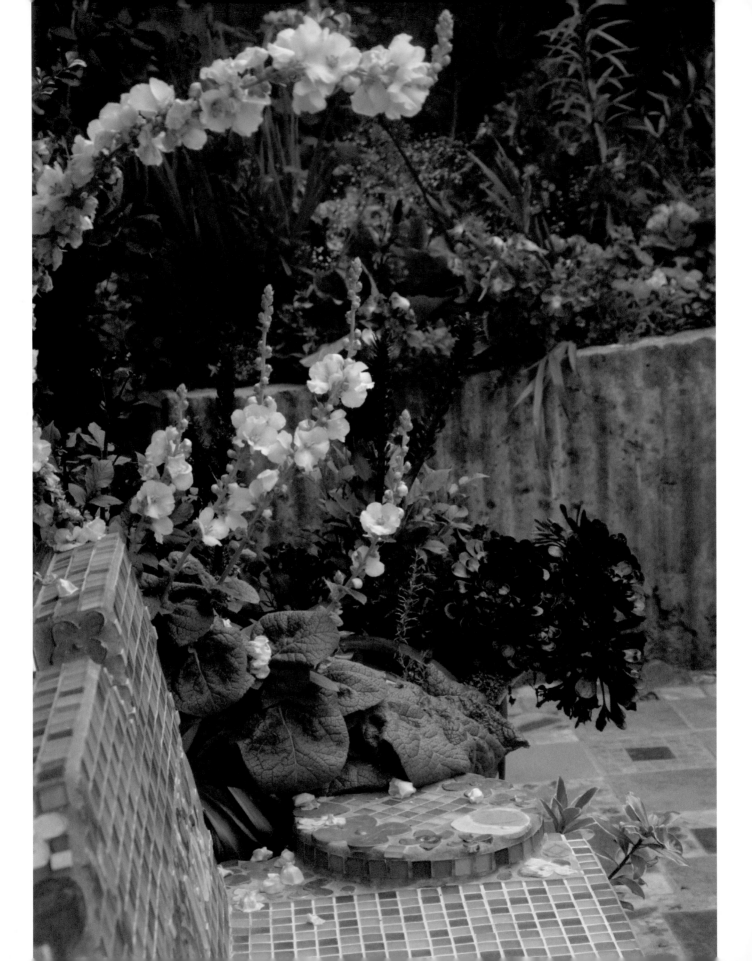

LEFT A palette of mauves, pinks, and yellows in the garden

ABOVE Matching flowers to paint

ABOVE RIGHT Matching leaves to pavings

Yellow: My Starting Point

I grew up in what I call a very oatmeal-colored house. Everything was beige—the carpet was beige, the walls were beige, all the furniture was beige. My father was a tall man. To my eye, he towered over a crowd. Being the weekend captain of his boat, he also demanded to be captain of the household. My mother, a Stanford graduate whose Scrabble scores reflected a daily diet of crossword puzzles and who looked like a magazine model in sleek designer dresses, was an "aye-aye," stand-at-attention sort of woman when it came to my father. My color journey began one dreary morning in my childhood when I was seated on a beige high-backed chair in our living room.

Yellow daffodils, seen through a wintry window trumpeting harmonious rays of spring, captured my eye. My ears were growing large as an elephant's as I listened to the drama happening in my face. As on many days, the curtain rose on my parents arguing over money and home expenditures since we had recently moved into a new house. This morning, the fight was over the color of the high-backed Mad Hatter's tea party chairs. My father said that the chairs' beige covering had done well in the old house and would do fine here. Mom cringed at the frayed oatmeal arms, saying "Keeyla, stop pulling on the threads." Mom wanted yellow.

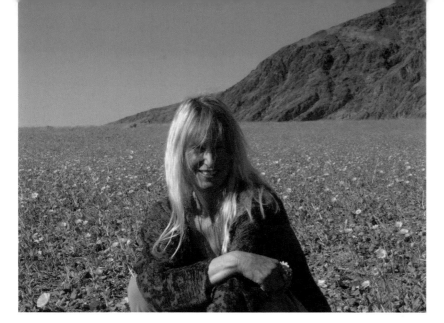

Dad's daytime job was being a lawyer. Remember that he's tall. I didn't tell you that one of the things he learned from sailing was how to puff up his internal winds like a storm swelling the waves or a gale propelling his boat forward. A lawyer, I learned quickly as a child, likes to win. The prevailing winds were on his side, as was the score I silently kept at the sidelines of my parents' arguments. In this case, the case of the yellow cover for the chair, I rooted for Mom and for yellow. As the argument heated up, I silently slid from the chair, escaping from the oatmeal, which was quickly becoming very sticky, out into the yard to sit by the yellow blooming trumpets of the daffodils.

Sitting by the flowers, like Mom, I became inspired by yellow. I went so far as to go into my room, find a white shirt, and embroider a yellow daffodil on it.

In a matter of weeks, two high-backed chairs returned to the living room, trumpeting out my Mom's triumph in a sunny shade of yellow. That night, as she was seated on her yellow throne, reading aloud Dorothy's journey on the yellow brick road, I decided that I too would follow Munchkin voices on an adventure into Wonderland. As yellow daffodils started this story, I knew it was fun to let flowers take the lead. Flowers are great starting points for gardeners.

Permission from Flowers

In answer to the tall woman's question, "What gave you the courage to be so colorful?":

Flowers do it,
So why, oh why, oh why can't I?
If flowers do it, why shouldn't you?

Take your color cues from flowers. Flowers provide all the permission

LEFT Me with yellow wildflowers in Death Valley

ABOVE Daffodils, my first color inspiration

you need to be colorful. I've been called a flower floozy. That doesn't hurt my feelings. Got the t-shirt. What flowers inspire <u>you</u> to be a flower floozy?

In my color notebook, yellow was the first color path I traced—from yellow daffodils, yellow lemons, and yellow corn to yellow honeysuckle and roses.

Continuing in my color journal, I made an entry about beige. I took a beige color swatch, labeled as the color I dislike, to the beach. When I realized that sand was the same color as oatmeal, I forgave my father for his love of beige: my family loved to picnic at the beach.

Beige. I still don't like the color beige. I like sand. Not so much for its beige color, but as a material to mush my feet into while my hands shape it into castles with sand-dripped turrets. By spending time with a color I dislike, I discovered that beige sand possesses many qualities useful to a gardener: what a perfect material to use as you play at shaping space! Are there some attributes of the color you've labeled you dislike that are in fact beneficial to you?

A tulip giving permission

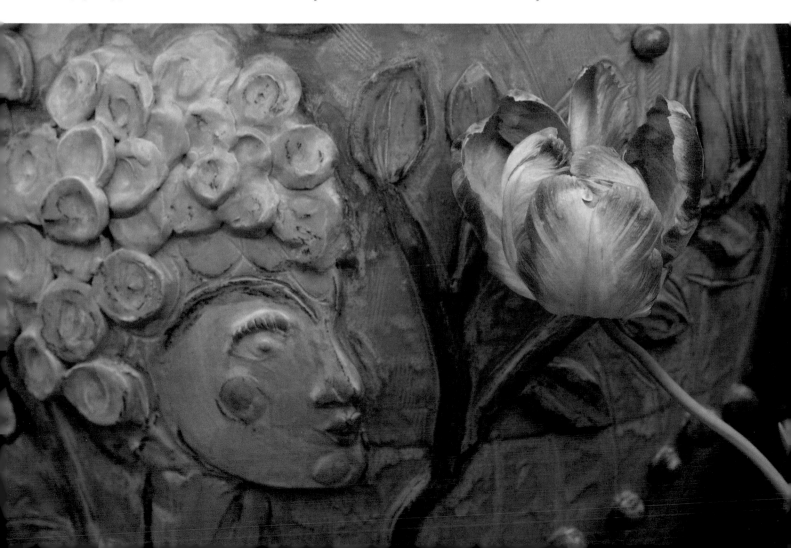

TRY THIS: Keep a Color Adventure Journal

Keep a color notebook to record your discoveries on your color journey. I use sketch notebooks from the art store. Select several colored crayons, pens, chalks, pencils that you are attracted to. One of the wonders of color is how personal it is. What attracts you is repulsive to someone else; go figure. We are not all the same. Now select a few colors that are repellant to you. All explorations are of interest regarding color.

Here are some explorations to try:

❀ Find a flower with petals of a color that is very attractive to you. Copy the color into your notebook. Write about the color. Do this for a few colors. What are some of the most attracting colors for you?

❀ Select one or two colored pens, pencils, or crayons of colors that are familiar to you from your childhood. Choose at least one color that you love or used to love and one color that you dislike. Make dots, squiggles, giggles of each color on a page, leaving room to write. Write about your color roots.

❀ Perhaps draw a stepping-stone, "follow the yellow brick road" path with one of your colors. Trace your relationship with the color you love through the years. Then trace your relationship with a color you dislike or are repelled by.

TOP A black-and-white drawing to start with
MIDDLE The drawing colored in
BOTTOM A tempting ranunculus with panther-pink petals

Then I made one more beige entry in my journal before shaking the sand off my beach towel and heading home from the beach.

My Uncle Art had a bachelor's-pad-style beach house on Old Malibu Road. A film editor in the motion picture biz, he was also a master gardener and seaside chef. I'd stay in what he called his "dirty room" on many a long weekend sleepover. "Dirty room" meant that he kept his beachcombing collections there. Already a rock hound in my own right, I didn't mind sleeping among stacks of sand dollars, halves of clamshells, and piles of antler-shaped driftwood. There I found another historical link to beige. Driftwood. My uncle was one of those resourceful artists who used what he found around him to create with. The beige-colored driftwood was strung up like holiday boughs over the fireplace, and at holiday time it glittered with colored lights. Like him, I had my work cut out for me out on the beachfront just down from his deck. Beige came into play with me making kingdoms in the sand. Busy excavating alongside beige-backed sand crabs, I'd keep an eye on my uncle collecting tide-pool treasures for what my family fondly called his "n-yumm n-yumm n-yumm" Sunday stews.

How did your story with the color you didn't or don't like turn out?

Gardeners in Colorland

As an artist I'm familiar with squeezing out paint to make a palette of colors to use on paper or the canvas in front of me. It's the same for a gardener. To start with, you select plants that you are going to use together in a particular part of the garden.

Before you select the plants, do you think of the colors and how they'll work together? The colors will set the mood, the feel, the tone of your whole garden or a section of your garden. The more connected you are to the colors, the more clearly they will speak. Work with commitment to these colors, especially your seed color once you have made your decision. Your commitment to a color will make both you and the garden happy.

While you can select two separate color palettes for each area of the garden—one for the plants and one for the hardscape materials—I work with one color palette for both the plants and the surrounding constructed environment. This makes for an integrated garden picture. Too many colors becomes very slippery, hard to handle, sliding right into a mud puddle of colors. Keep your palette simple, clear, and alert.

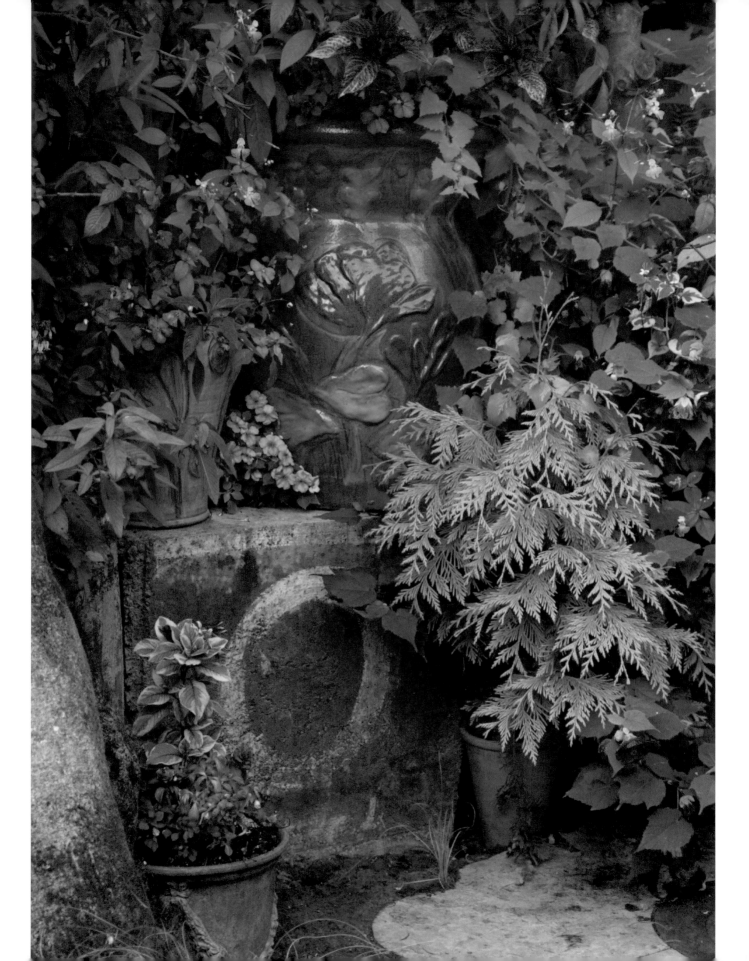

ABOVE Introducing Emerald,
my color muse

LEFT Colors extending through the
whole space

BELOW LEFT Flowers giving permission
to put shocking pink with orangey red

BELOW RIGHT Zinnias, petunias, and
aeonium playing a riff on reds and pinks

Help from a Garden Muse

Miss "I Want to Get a Word in Edgewise" just popped in from the realm of inner voices to pay a visit. I call this voice Emerald, my garden muse. When a local nursery approached me to teach a class on color, I replied, "Sure, I'd love to." In reality, I didn't know what I'd teach because I was just in a silent flow with color. I said to myself, I'm going to start observing what I do. That's when Emerald came in on the look-to-your-left, look-to-your-right hokey-pokey color dance. While I was selecting a pink flower and contemplating what to put with it, the voice guided me to put one plant to the left and one plant to the right.

Emerald appears to me as a cross between Tinkerbell and a hummingbird, with the sting of a bee. She likes to get attention, thus the stinger. Her hokey-pokey dance gave me a great clue about how to focus my attention on color. For example, if I was selecting a flower that I thought of as just pink, the voice guided me to put one plant to the left and one plant to the right and have them move in opposite color directions. With pink what I found was that one pink, the pink I placed to the right, was more purple, a purple-blue pink, and the pink to the left was oranger, a sort of salmony or orange pink. The purply pink was cooler in feel, the salmony one warmer. Naturally, the next question was, Do you want your color palette to be cooler or warmer?

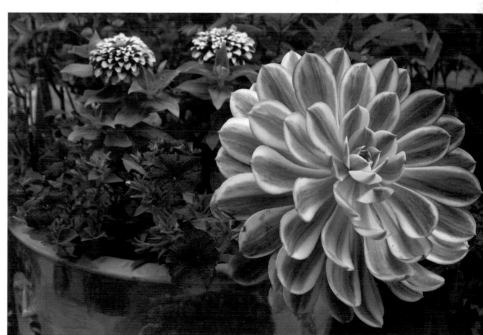

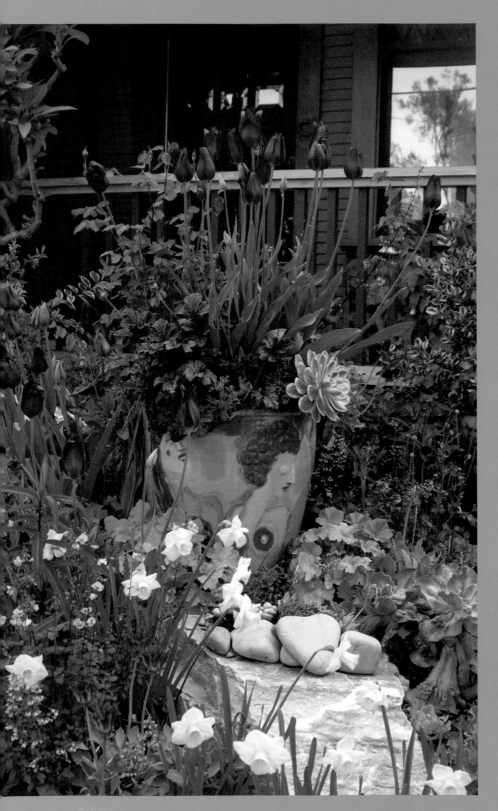

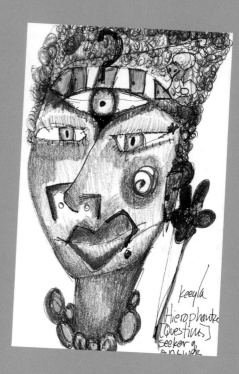

TRY THIS: Ask Your Muse Color Questions

Asking color questions is extremely helpful. In your color journal make a page for questions that arise as you explore and research color. For fun, direct your questions to a garden color muse. Is there a storybook character or your own variation that would keep you amused? When you get stuck, ask, What's next? If your color muse is anything like Emerald, she will show up whether you want her to or not. With great answers, I might add.

Take your muse to the nursery to do the look-to-your left, look-to-your-right hokey-pokey color dance. Start with a seed color, then put one color to the left and a cooler color to the right. Do this for three different colors. Hokey-pokey, turn yourself around. That's what it's all about with color. By focusing on the variations of colors you become attuned to the factors that make up color relationships. This is key in making a color palette.

LEFT A questioner and seeker of answers

FAR LEFT Women of Paradise pot pulling together variations on pink, purple, green, and orange

RIGHT Look to your left for warmer colors, look to your right for cooler colors

BELOW Hokey-pokeying into fearless color

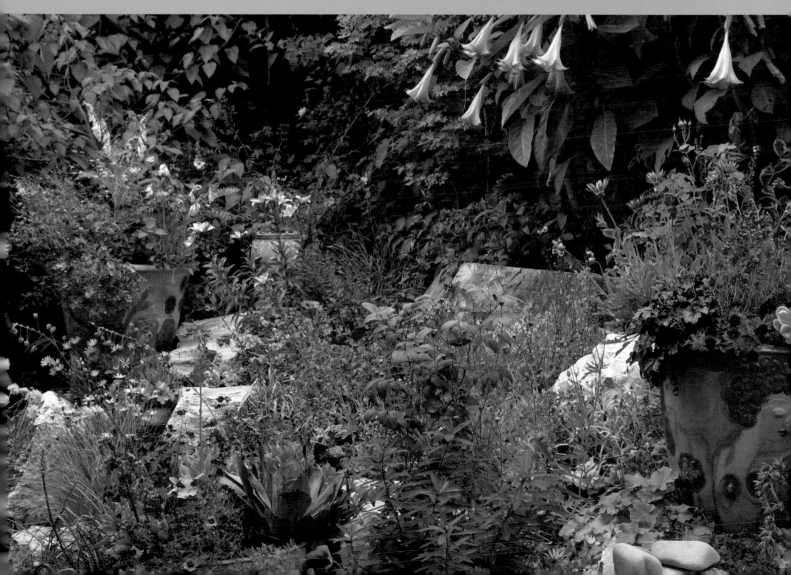

Basic Principles: Harmony and Contrast

Harmony and contrast are the primary concepts in making color relationships. Colors are either in harmony with each other or they are in contrast to each other. For your color palette, after you select your seed color, all additional colors will be in a relationship of either harmony or contrast to that color. I advocate strength and loyalty. Be a committed lover! Stay with your seed starting color. It's the root of and the route to an amazing garden.

The first principle of color is harmony. Colors that are harmonious sing together. They flow. They dance. Harmonious colors are beautiful together. They are similar to each other. They are close in hue. They get along. They are delightful. Happy. Joyful. Splendid. Like beautiful chords in a song. Harmonious color combinations bring beauty and harmonious feelings of well-being into the garden space.

Contrast is what is going to give our color palette punch, pizzazz, drama, playfulness. What we select for the contrasting color to our seed color will determine what degree of boldness we are working with. Contrast is a matter of degree. Contrast is some degree of difference, of opposition. A garden of all contrasts would be quite dramatic, if not chaotic.

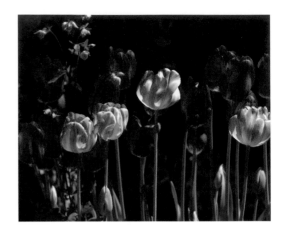

ABOVE Tulips in fearless harmony

RIGHT A garden scene humming with harmony

BELOW Objects of art in harmony with plants

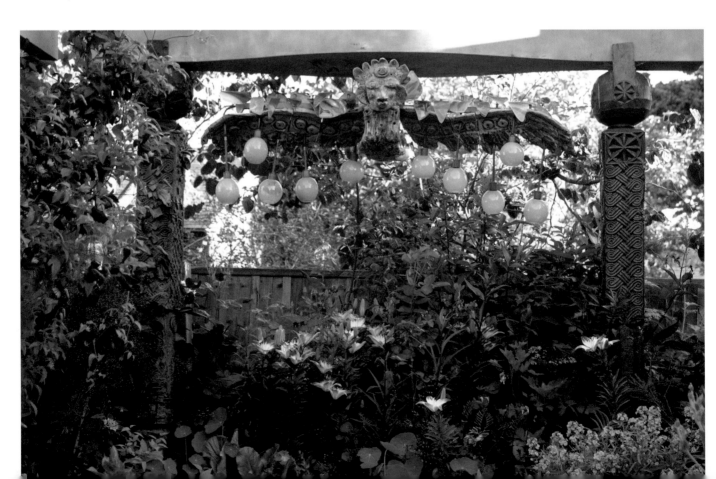

This simple equation of harmony, with harmonious color relations, and contrast, with contrasting color relations, holds within it the seed of the whole story of working with color. Here's a preview of what I'll explain again later, after a journey through the colors. One way to create a color palette is to select two contrasting colors and back up each color with similar, harmonious colors.

First start with one color—let's say red—and make a harmonious color palette to go with that color. I usually add just one other color group to my seed color. With red, I first select either the blue-red group or the red-orange group. Emerald asked me (and your muse might ask you): "Are the color hues that you want for your backup colors warmer or cooler than your seed color?" If my seed color is purple, then cooler backup colors will be purple-blue and warmer backup colors will be purple-red.

That takes care of the harmony side of the equation. The seed color is the first element of the harmony side of the equation. The

ABOVE A composition in bold contrasts

RIGHT Contrasting reds and greens: begonia and polka dot plant

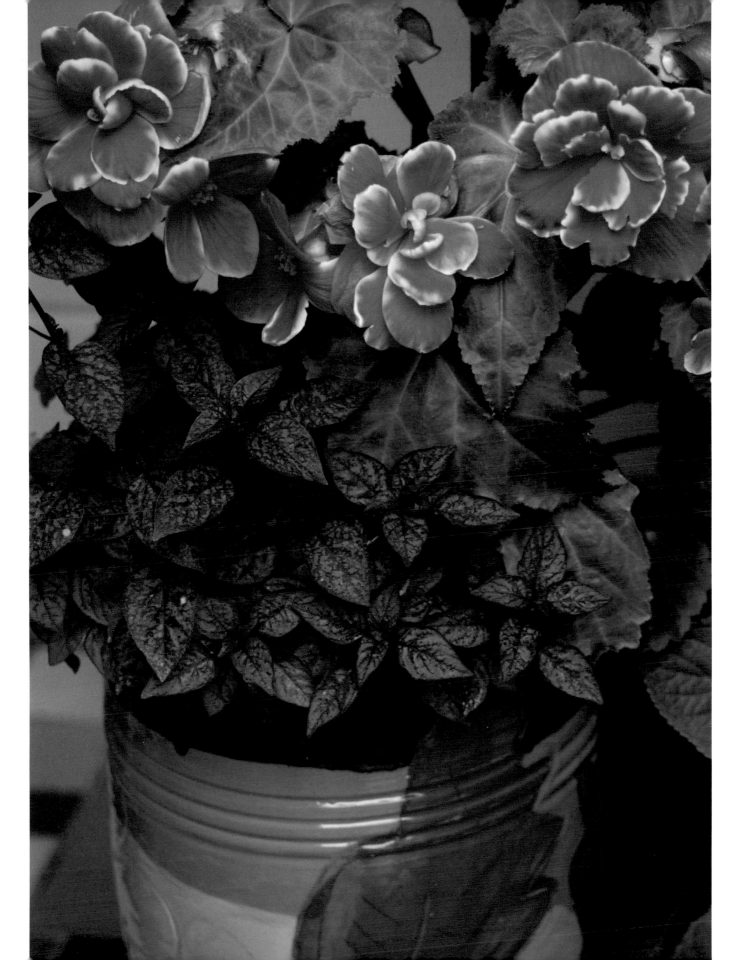

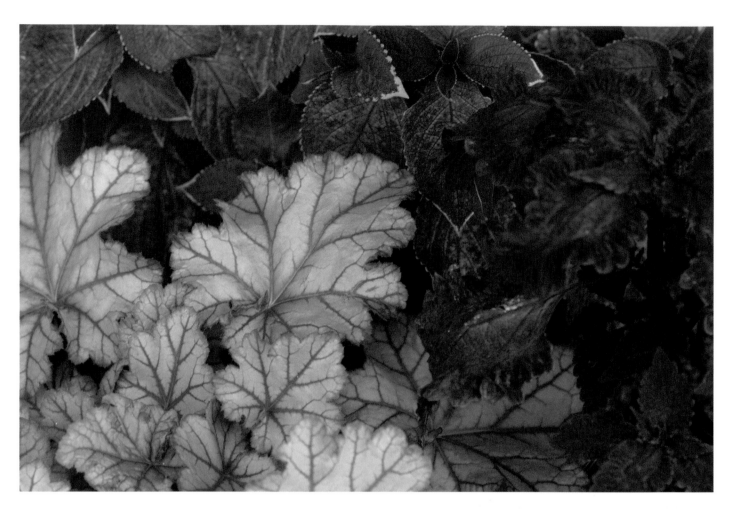

second element is the harmonious chord of backup colors. You could even think of the seed color as the lead singer in a girls' group and the harmonious chord as her backup singers. The harmonious chord is a slight but not very great contrast to the seed color.

The other side of the equation is contrast. I start with one color for the contrasting color and add backup colors in harmony with this color. A contrast can be subtle or bold. The difference between the seed color and the contrast color will set the feeling tone of your color palette.

We will talk more about building color palettes after traveling up and down my color triangle.

TOP When coleus meets heuchera

ABOVE A color contrast suggestion made by one flower

ABOVE More contrasting leaves and
flowers: yellow-greens and purple-reds

RIGHT Contrasting clusters: a yellow-green
cluster and a purple-red cluster

LAYOUT #1 KEEYLA MEADOWS GARDENS & ART

ABOVE The color muse commenting on color relationships

LEFT A color palette applied to the garden plan

TRY THIS: Combine Colors and Ask What's Next

Take your color muse and notebook to a nursery. Select a starting color. Find a plant or flower that is in harmony with your seed color. Now find a plant that is in contrast with your seed color. Ask your muse, "What's next?" Perhaps what's next is to plant these plants in a container to observe your response to the color relationship as they grow. Do you like this color combination enough to work it into your garden?

LEFT A color combination that might surprise you

Keeyla's Color Triangle

Before I met my muse, I didn't know that I had a color triangle. It has since become my reliable compass bringing order and clarity to the vast landscape of color.

My color muse, Emerald, appeared to answer my question, "What's next?" What's next after knowing that the primary relationship of color is harmony and contrast? "There's the color wheel, you fool." She talks like that to get my attention. She can be a stinger. Duh! Of course. The study of color wasn't invented yesterday. So I took time out from fun gardening to go to the library to research color, discovering the color wheel, but the idea of a color wheel didn't root inside of me.

Emerald then sent me to the park for a ride on a carousel. I got off feeling dizzy, the same way I felt when looking at the color wheel. "Emerald, help! There must be another tool to help navigate through the world of color." My head still spinning, lying down on the grass, I heard Emerald tell me to look up at the clear blue sky. I looked up above, searching for a comforting shape, something stable and grounding. An image of a triangle popped into my head with blue at the top, like the sky overhead; red at the bottom right; and yellow at the bottom left. Color kingdom or queendom, come to order! And this is how I got my teaching tool, one I've since used to teach many a group of gardeners about color.

Keeyla's color triangle

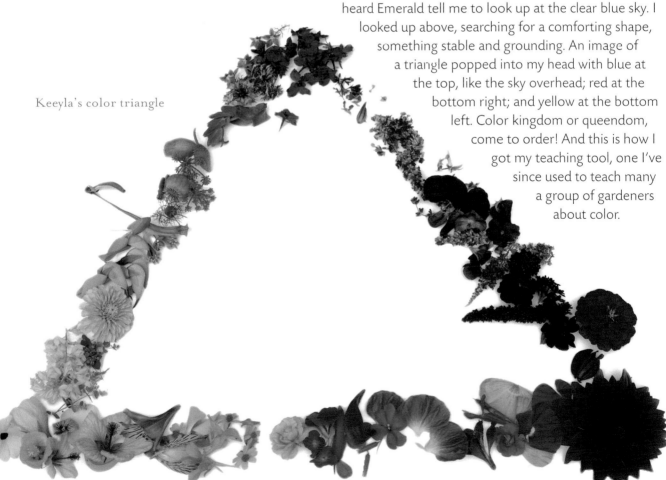

Open your inner eye to
meditate on color

TRY THIS: Draw a Triangle and Practice Visualizing Colors

Draw a triangle with points labeled or colored blue at the top, red on the bottom right, and yellow on the bottom left. Now divide each of the lines between these colors in half. The colors between the primary color stars—blue, red, and yellow—are purple, orange, and green. Label or color these, the secondary color stars. Purple is what you get when you mix pigments of blue and red together. Orange is what you get when mixing red and yellow, and green when mixing yellow and blue. These are the primary players in the color world. Each of these colors makes a perfectly wonderful seed or starting point color for a color palette.

Draw a color triangle

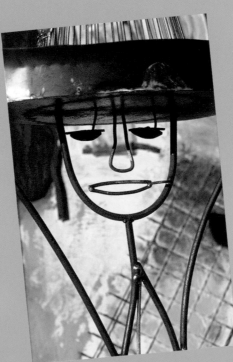

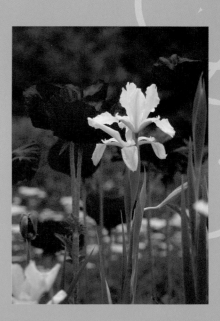

Yellow face, yellow iris

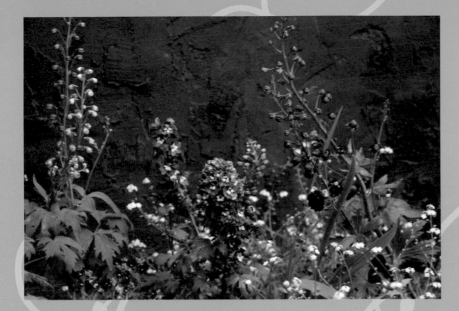

Blue hair, blue wall,
blue delphiniums

Look at your triangle drawing for a moment. Now close your eyes.
Imagine that you can see the triangle and look at each of the colors.
Start with the primary colors. In your imagination, look at blue at the
top, red at the bottom right, yellow at the bottom left. Open your eyes
and look at the actual card. Do this a few times. Practicing helps your
visualization skills, which come in handy when you are designing with
the colors. Now do the same thing with the secondary colors: purple,
orange, green. Write down any insights you had. Or just take a note on
what it felt like to do this visualization practice.

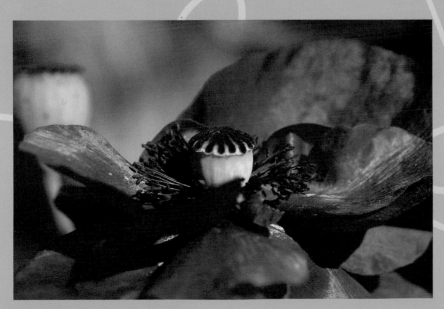

Red woman, red hat,
red flower

LEFT A divine cascade of color

My color compass for the garden is in the shape of an equilateral triangle. All sides are equal, with a color star at each of the corners. The stars at the points are the primary colors: blue, red, and yellow. Between blue and red is the blue-red leg, road, or path, with purple in the middle. On the red-yellow path, orange is in the middle; and between yellow and blue, there is green. Simple. Stable. Yeah!

All the essential ingredients for working with color are right there in a very stable shape—an equilateral triangle. With this tool in hand, let's get to know our ingredients for making colorful gardens. Just as you want to know the ingredients to make a great meal, you'll also want to know what your colors are for making colorful gardens.

Getting to Know Your Color Ingredients

Get to know your ingredients by traveling through the colorful landscapes of divine attributes and emotional qualities suggested by each color in the color triangle.

Divine Attributes of Color

I don't know how else to say it. Color just seems sublimely divine to me. It's magic. It comes from light. As in nature, gardens are playgrounds for light to enter our earthly abode. Identify what essential qualities you associate with each color, sublimely leaving the slimy side of things for the compost heap. Here's my list of divine qualities of colors. Please add to my list. Keep this chart of qualities handy as you explore each color.

SAMPLE CHART OF QUALITIES

- ❁ Blue: openness, wonder, awe, inspiration, sublimity, purity, expansiveness, flow, freedom
- ❁ Yellow: optimism, enthusiasm, confidence, curiosity, magnanimity
- ❁ Red: boldness, excitement, courage, sexiness, alertness
- ❁ Purple: intimacy, investigation, transformation, royalty, mystery, surrender
- ❁ Orange: willingness, power, effervescence, liveliness, contemporaneity, edginess
- ❁ Green: compassion, nurturance, acceptance, growth, gratefulness, restoration, meditation

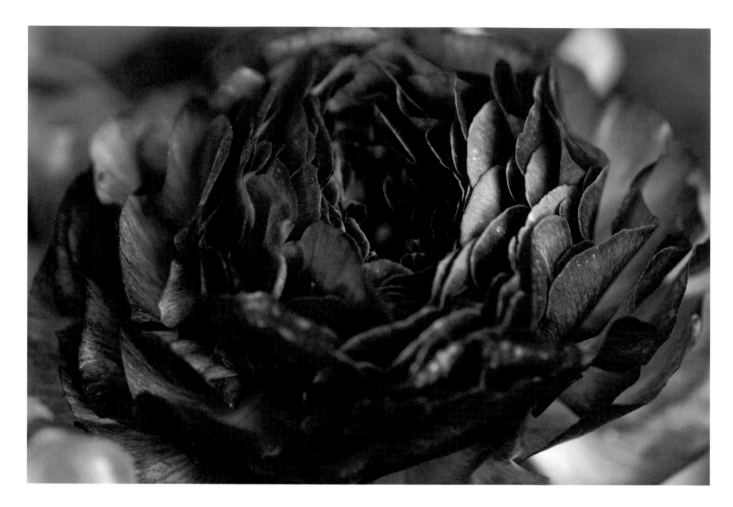

Here are more suggestions of qualities to associate with colors: love, strength, forgiveness, persimmons. Persimmons! That's my computer talking to you. I was typing *perseverance* and the computer said *persimmons*. They are divinely orange. Okay, back to work. More divine qualities: joy, comfort, playfulness. Now add yours. Keep this list handy for inspiration when making your color selections. If you want an area of your garden to be inviting, joyful, full of enthusiasm, look at your list to see what color you associate with these qualities.

Color and Emotions

Just as a singer needs to deliver a song with emotion to have it connect, a gardener can sing her song with emotional impact through her use of color.

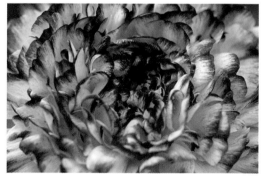

TOP Magenta: lushness, mystery, surrender
ABOVE Blushing white: playfulness, yumminess, frivolity

TRY THIS: Write a Chart of Your Emotional Flow

Do you associate your emotions with different colors, or even sort of "see" them as having colors? Compare your chart of qualities and colors to your chart of emotions and colors. Now write some sentences about how different colors make you feel. Your survey of the feelings you associate with color might influence your decisions about where you want to place different colors in your garden.

ABOVE Feeling effervescent?

BELOW Dutchman's pipe expressing a somber mood

Here's my journal entry:

Yellow—makes me happy, optimistic, enthusiastic, confident—I might put yellow at the front of the house.

Red—makes me feel bold, independent, muscular, able to say, "Why not? Let's party. Let's have fun. Let's dance. Let's get it on." I might want to put red near a patio or as the backdrop to an outdoor kitchen.

Blue—makes me trust in the sublime, slow down, go with the flow. I might put blue in a meditation garden or quiet nook.

Purple—is a willingness to go into uncharted territories, seek out secrets, transform, transcend. I might put purple in a part of the garden I haven't been able to figure out.

Orange—makes me glow; dare me. I'll tell you I can. I will. I want to. I might put orange in an area where I plant an orchard or a victory garden.

Green—makes me feel compassion, acceptance, gratitude, willing to grow and learn. Green goes anywhere in the garden. It's a primary color of plant foliage.

Another approach to your garden is to treat it as if you were writing a musical. Adding more color to your garden has the potential of making your garden more dramatic, even more theatrical. As you put colors into relationship, they are almost like characters in a play. When I get to organizing the space for a garden, one way I conceptualize the space is as a stage. In your color musical, sing out your colors with compelling emotions. Blue started a whole musical tradition: the blues. Color can communicate a wide range of emotions. What are the emotions you are singing when you sing the blues, the reds, or the yellows?

Move around your garden with an eye to what colors, what emotions, what color qualities you want in each location.

Tasting Your Color Ingredients One by One

Now, in order to build a better color combination let's do a thorough tasting of our ingredients one by one. Our top three essential ingredients on this color expedition are the colors at the triangle corners: blue, red, and yellow. In some way these colors are part of whatever color we are working with, so we want to explore the flavor potentials of each of these colors. Next, we move on to the secondary

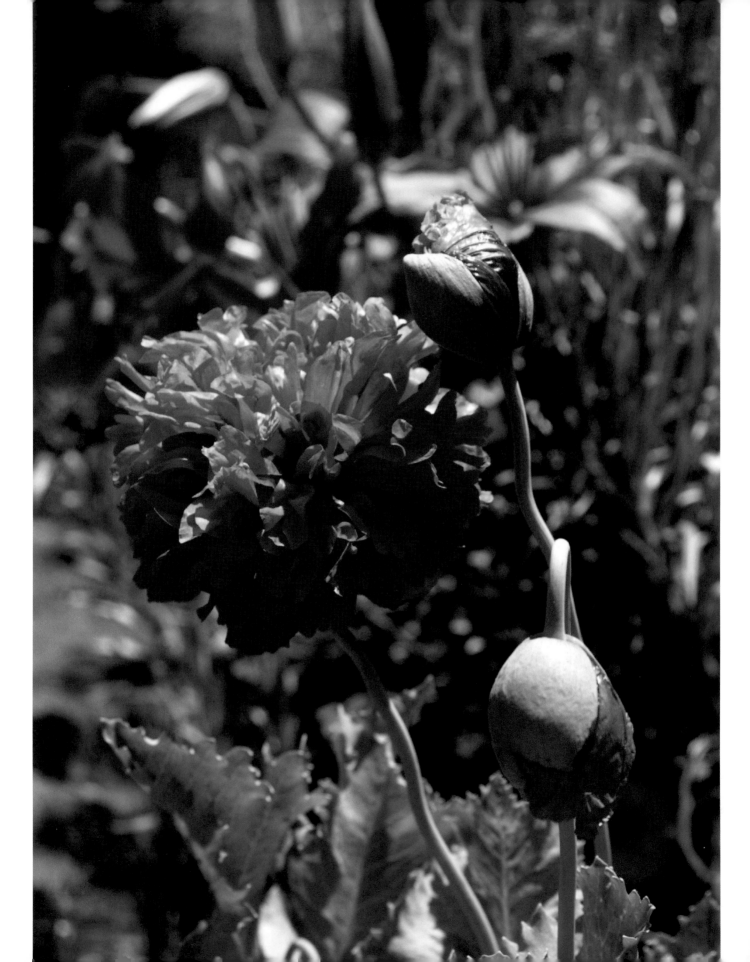

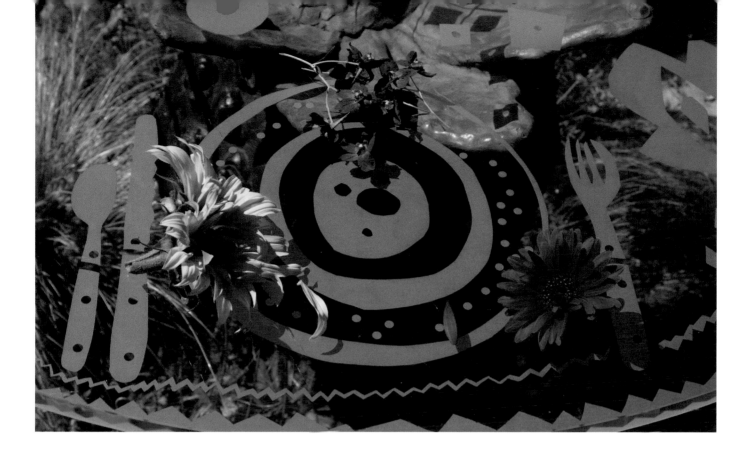

ABOVE Inviting your colors to lunch
LEFT Imagine singing the reds
BELOW Red hibiscus, blue sky

stars or flavors: purple, orange, and green. These colors are rooted in our first colors, yet we want to taste them independently. Making a meal of colors is perhaps not a perfect metaphor for the garden, but knowing your ingredients is. It's important to have spent time "tasting," testing each color on its own. Getting to know that color, cultivating your relationship with it gives you a leg up on using it well in the garden.

The heart of knowing your color ingredients comes from selecting the actual plants and materials of each color that you want to put in your garden. To facilitate this process I've made a worksheet with two sections: one for plants and one for hardscape materials. (On the plants list, "Other plants" is for cacti, succulents, orchids, or other specialty plants that you collect.) Copy this worksheet for your notebook and fill out one for each color. These will become your ingredients lists for each zone of your garden.

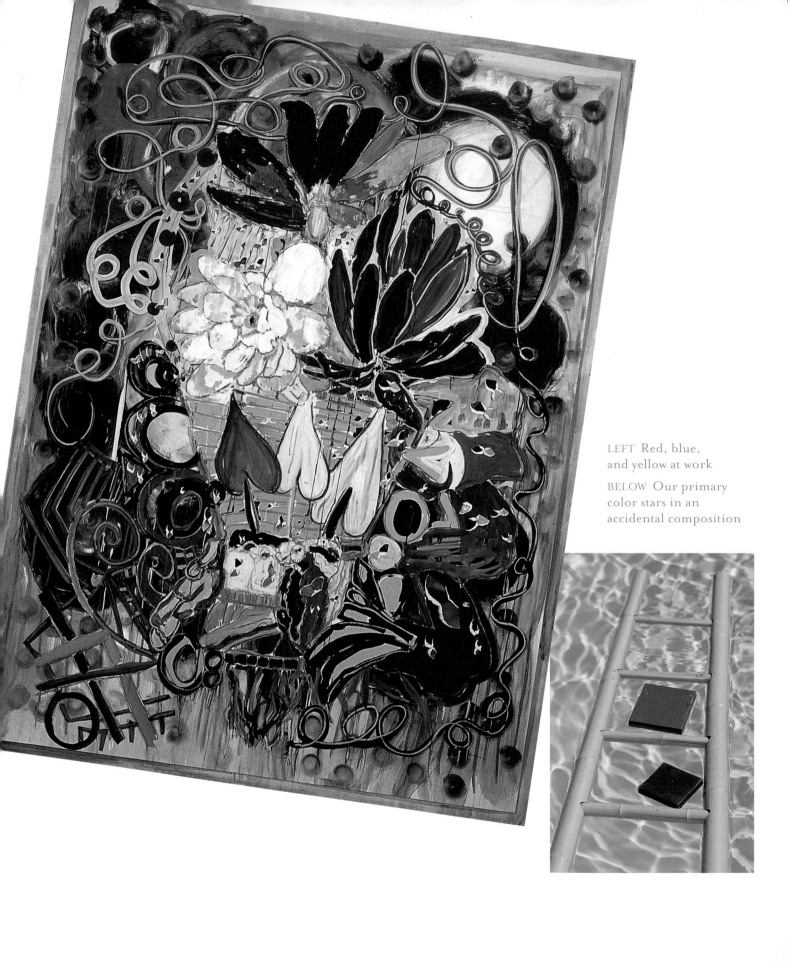

LEFT Red, blue, and yellow at work

BELOW Our primary color stars in an accidental composition

Color Worksheet for _____

[name of color]

COLOR GARDEN PLANTS

Ground covers: _____

Perennials: _____

Annuals: _____

Bulbs: _____

Vines: _____

Shrubs: _____

Trees: _____

Grasses: _____

Other plants: _____

COLOR GARDEN HARDSCAPE MATERIALS

Rock: _____

Paving: _____

Walls: _____

Planters: _____

Furniture: _____

Sculpture: _____

Art: _____

Paint: _____

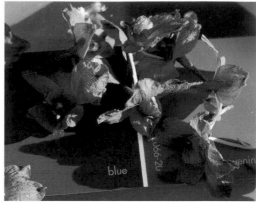

After reading each of the following color sections, take yourself on a color date to the nursery or botanical garden to identify plants of that color you'd like to use in your garden. Do the same for your materials. This is at the heart of knowing your ingredients. Once you have fallen in love with your ingredients and are sure you want them in your garden, deepen your relationship by reading up on your plants and materials.

Blue—All Good News

We're going to start our color palette journey with blue. A visitor in my garden, when looking at one of the blue ceramic tiles in the paving, told me that in Portugal it's a tradition to bring the sky to earth in the form of putting blue in the garden. If I put my triangle upright, blue is at the top because it points to the sky. The garden choreographs the dance of light as it comes to earth. Painters have observed this for centuries. The light comes through the blue sky leaping, spinning,

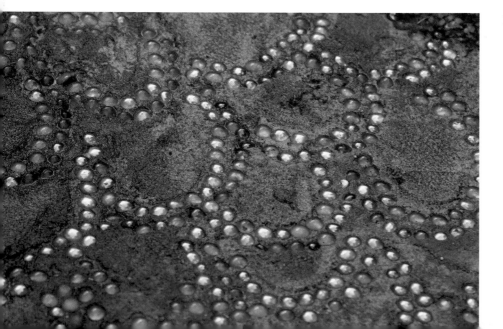

Blue in the hardscape: a marbleized patio

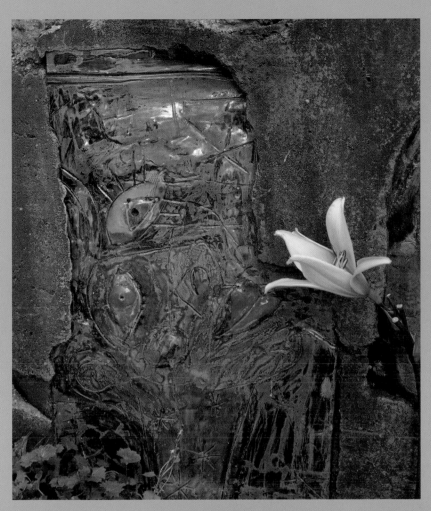

TRY THIS: Write a Poem or Paragraph about Blue

One of the wonders of the garden is how it invites the sky to earth. How does blue affect you? Since you have your journal open, describe your favorite flavor of sky blue.

Then record in your notebook how the sky affects you four times a day. Record the hue of sky in the morning, afternoon, evening, and night. What were the emotions that each of these blues evoked in you? What song would you be singing to the title "I've Got the Middle-of-the-Day Gardener's Blues"?

TOP Renewed in a blue cocoon

TOP RIGHT Ceramics bringing the sky into the garden

RIGHT Singing to the sky with the birds

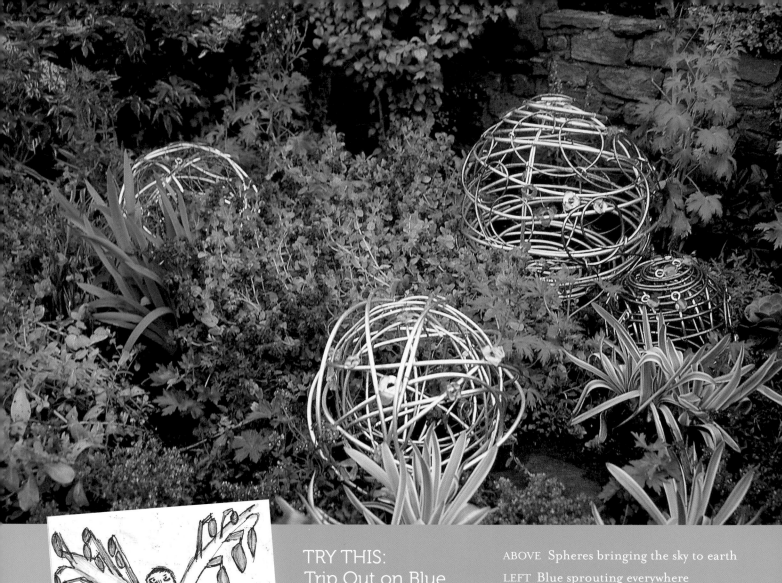

TRY THIS:
Trip Out on Blue

Before leaving blue, let's take one more delicious mouthful. Take yourself on a blue date. Where do you want to go to feast on the color blue? Do it. Record your findings.

Then take yourself on a museum date. Look at how different artists have worked with blue paint. Share your experience with a friend.

ABOVE Spheres bringing the sky to earth

LEFT Blue sprouting everywhere

BELOW Blue delphiniums with yellow eyes

pirouetting on all the upturned surfaces of leaves, flower petals, and pools of water.

It might be that all good news comes in tones of blue—especially if a patch of delphiniums just burst into bloom.

Blue is a beautiful color. Blue is a color of divine inspiration.

Although blue is cool, it's a cool that can sizzle. One shade, Majorelle blue, is so electrically enticing that a whole garden—Majorelle Garden, in Marrakech, Morocco, designed in 1924 by the French artist Jacques Majorelle—is built around that color. I saw Majorelle blue in a magazine and totally fell in love. Three years later, I got on a plane headed for Marrakech! I had never planned to visit Morocco, but that blue really struck a chord. I had to see it in person. And as it turned out, it was well worth the trip. That blue has inspired many a garden creation for me and others.

When I visited, people with cameras up to their eyes "flowered" the Moroccan garden, which is mostly planted in cactus and succulents. And there were legions of turtles sunning around the pools with the tourists. Everyone was happy, relaxed, inspired while "drinking in" that color blue. It's a blue that quenches the thirst of the soul. Coming home, I painted walls and pots in Majorelle blue and planted bouquets of saturated, deep, luminous, violet, sky-blue-hued flowers.

> ## My journal entry for blue sky:
>
> Midnight on Lake Maggiore, Italy, is like a planetarium of stars gleaming in the deepest, most blueberryiscious indigo blue imaginable.

Red—Dance It Hot! Hot! Hot!

Red is our next color star on the color triangle. Where blue is cool, red is hot. "Some like it hot" describes red people. For me, red is to put your wig hat on, put on your high heels, put on your red dress, and dance. Red is sexy. Red says—as one of my dance teachers also said before a performance: "Now is no time to be shy! Give it your all, ladies!" Sometimes we need that permission to let the bull charge out of the pen. Fiestas and carnivals are decorated in fiery reds. Red pushes the territory, breaks boundaries, takes you out of your comfort zone into new regions of expression.

A gardening friend tells me that she hated the neighbor's intrusive red bottlebrush plant until she realized that she could tone red down by putting it in harmony with other colors. She transformed her dislike of red by planting bronzy red foliage and pink flowers next to and beneath the intrusive red plant, effectively getting rid of red sticking its tongue out at her. Are you on friendly terms with red?

Red is more action than reflection. We use red as a warning sign, and as with traffic lights, red is our signal to stop. Ironically, my dance teacher says, "Stop thinking about it and just do it!" Sometimes it's good to approach your garden in a fever, in a rush, with passion, alive, alert in a fiery flush of red. Once you have all your ingredients in place, that is!

TOP LEFT Red dahlia, red chameleon plant leaf, red color chip

ABOVE Red as in banana leaf

BELOW Red stems: A place to rest

RIGHT Stalking red

In a strawberry red mood

Red rafters in my kitchen

TRY THIS: Take a Color Date with Red

Is there a red place that calls to you? Go there.

Answer these questions: Is red a color that you want to use in your garden? Is red a color that you have some fears about putting in your garden? Can you imagine painting a door in your house red? Or a wall? When I redid my kitchen recently, I tore the wallboard off the ceiling, exposing worn rafters. I painted them red. This was a bold move. Just the other day, when I was drinking wine and eating cheese at sunset with friends, my guest remarked, "I like looking at your new red ceiling." Is there a bold move you'd like to make in your garden?

What parts of your own personality resonate with red? Does red spell romance for you? How do you want red to act in your garden, bold or romantic?

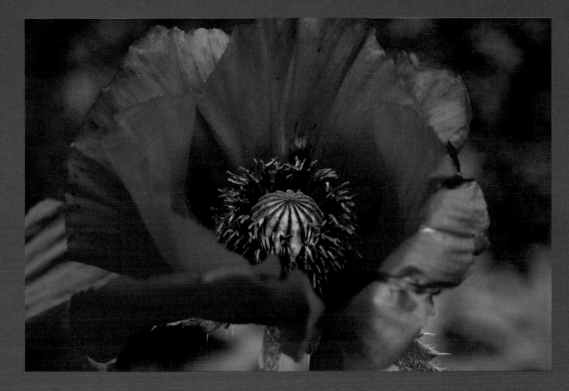

Red in love:
an Oriental poppy

Red nude in the
garden

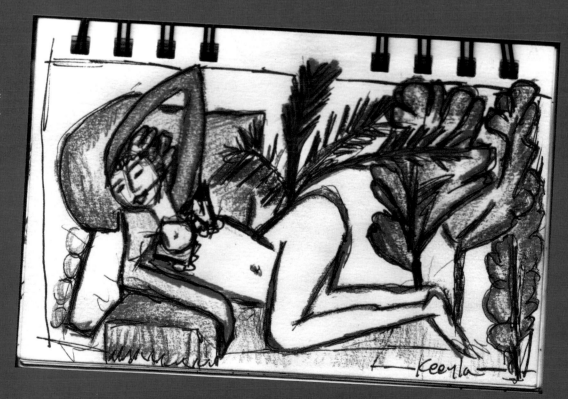

Large bronze woman watering

As blue is sky and water, red is fire and the iron-filled clays of the earth. Red is the dance that celebrates being in a body on earth. It's this celebration that links us with the energies that root our passions to our survival and vital health. In the Hindu energy system of chakras, red is our root color. So you might think of red helping us define our existence, linking us with the earth for our survival, vitality, and health. Red has that instinctual, combustible quality of fire.

Iron in the soil produces reds. Many rocks are red toned. Consider using red-hued natural materials in your garden. Many of my gardens feature red in the rocks. Red definitely says, "We will we will rock you!"

One of my personal favorite flowers and favorite garden ingredients is the red poppy. Like many of my inspirations, this one

ABOVE A hot-looking pot

ABOVE RIGHT Coral tree in bloom

BELOW Talking to a parrot tulip

made me fall in love with it while I was traveling. Touring Italy along with fourteen other art lovers, through the train window and then in person on the slopes of Pompeii I saw red poppies blooming in abundance. As we were on a drawing trip, I took my sketch pad to sit among the poppies, where red called lovers to sleep and dream in her embrace.

In the garden red offers numerous opportunities. Red encourages you to think outside the box, go beyond boundaries, run those traffic lights. With red in the garden there is no reason to stop!

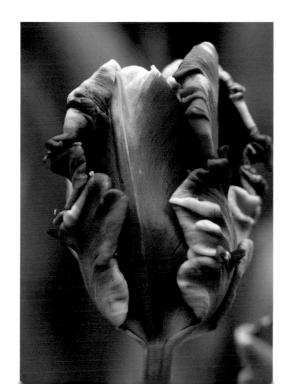

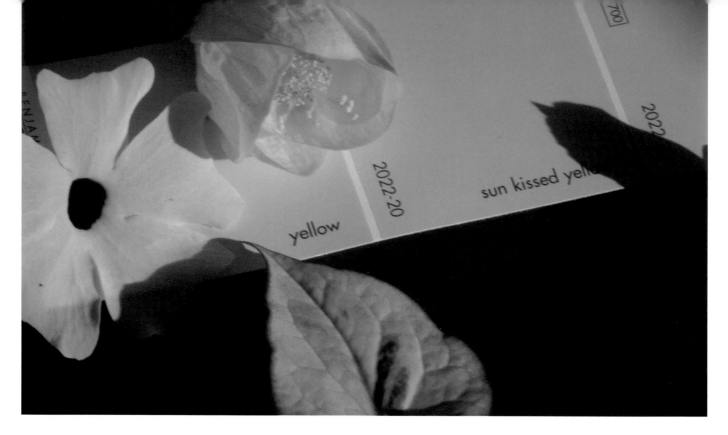

Yellow—Yes with a Mile-Wide Smile

Yellow is the third and last of our primary color stars. Yellow as an ingredient of your color palette means taking a walk on the sunny side of the street. Yellow adds brightness and light to any situation. Because of yellow's enthusiasm, like the sun announcing the day, many kitchens are painted a ready-to-start-the-day yellow. Speaking of kitchens, I shall return to my yellow brick road story.

ABOVE Sun-kissed yellow from the garden
BELOW LEFT AND RIGHT Sunny as a sunflower

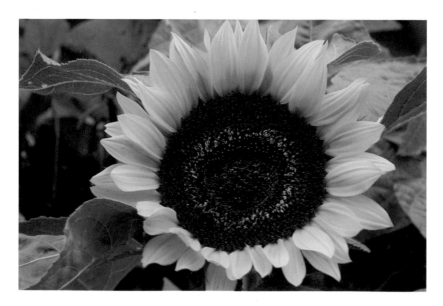

RIGHT A dynamic voice: yellow in
Olympic flame tulips

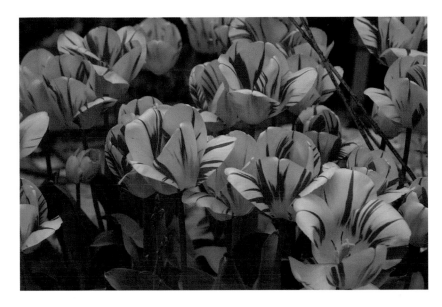

Art inspired by planting yellow
vegetables

TRY THIS: Plant a Yellow Edible Garden

Plant a summer menu of vegetables in a
yellow edible garden. Yellow 'Lemon Boy'
tomatoes are my favorites. Corn, squashes,
yellow beans, peppers—they all come in
shades of finger lickin' yellow, leaving
smiles all around the dinner table.

My mom loved to cook. My family came together over eating.
While my dad was a king-of-the-road kinda guy at the table, he had
a yellow streak of infectious, magnanimous appreciation. A man who
loved to eat, he could be counted on to bring home the bacon, and
my mom cooked it. The "story of the bacon" at the dinner table kept
my parents' marriage on an even keel. Mom cooked from the sunshine
of the garden to please the captain at the table. Yellow summer corn
came marching from the kitchen breathing out an aromatic steam.
Simple fresh shucked corn on the cob, buttery corn bread, corn fritters,
summer corn chowder were all part of Mom's high-as-the-sky Fourth
of July menu. Lemon squares, lemon pound cake with summer berries,
and lemon meringue pie all made with lemons picked from the garden
cemented the peace in our house.

As a single color, yellow is forever cheerful. Yellow can be quite
simple and direct in its offerings, nothing hidden, no secrets, just the
brightness of newborn ducks and chicks. All warm 'n fuzzy. But put
yellow on the back of a bee, striped in black and yellow, and it might
threaten to sting. Striping yellow with black in broadly contrasting
bands can warn of strong emotions and make dramatic statements.
Yellow combines with dark colors even more boldly than white because
of the "yell" in yellow. Yellow has a dynamic voice. One of my favorite
dramatic contrasts is yellow with any dark red.

Yellow is a worker in the color world. It backs up the darker colors,
not letting them fall into gloom. It lights up dark regions of the garden.
Luckily for gardeners, many shade-loving plants come in yellow. Plants

must have worked out an agreement with insects to be like flower lights in dark spaces, guiding the bugs to their treasured nectars. Shade is often made by trees, which cause root competition, but you can get yellow into these shady spots by using containers. Just set a pot of yellow-flowering or yellow-foliaged plants in a root-bound dark nook. Yellow-flowering begonias make bright lights, as do calceolarias, also called purse flowers. Here's a sunny idea: you could plant them next to a purse fountain. Yellow-foliaged heucheras are also good candidates for shade.

Now we are going to get to know the colors in the middle of the color triangle. A basic lesson in mixing colors starts by mixing each of the primary colors with another primary color. Mix blue and red, and you get purple. Mix red and yellow, you get orange. Mix yellow and blue, you get green. These are the colors in the middle of each of the color triangle legs. This triangle has great legs!

ABOVE Yellow yelling from tulips and alstroemeria

BELOW Yellow for shady spots

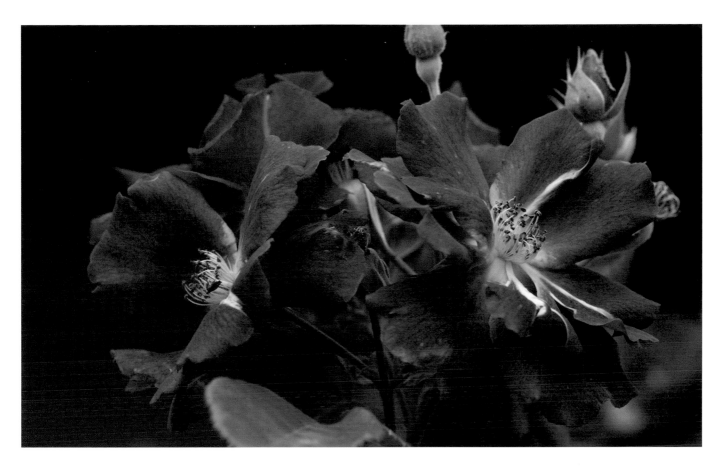

ABOVE Purple
RIGHT Orange
BELOW Green

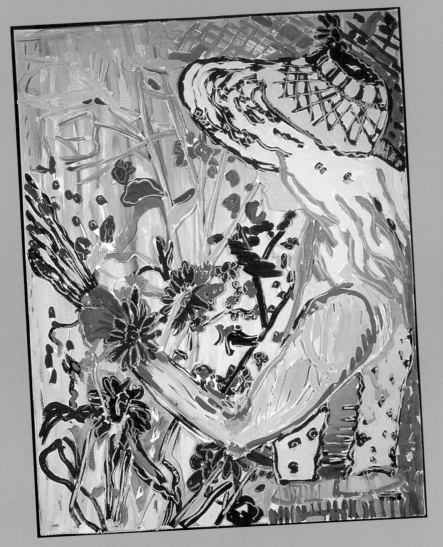

LEFT Blue, red, yellow—winners of the primaries

TOP Dahlias for a courageous assortment of reds

ABOVE Sunshine in one enthusiastic flower

BELOW Blue like only a delphinium can do

TRY THIS: Create Harmony and Contrast with Primary Seed Colors

Each of the primary colors makes a wonderful seed color. Choose one as your starting seed color. Make a backup harmonious color chord to your seed color. Now select another primary color for your contrast. Take out your color garden worksheets for the primary colors. Imagine what a garden might look like with each of these colors being the seed color for the harmony side of the equation and one of the other colors as your contrast. How can you use your contrast color to support and draw out, but not overwhelm, your seed color?

Purple—The Royal of Colors

Purple is that place where evening shadows gather splendor. Purple is the shadow. It's the between time, between day and dusk, night and morn. Purple leads us into uncharted territory; purple boasts of deep transformations. Purple hides our secrets from prying eyes, as shadows make safe havens for lovers in crowded city parks. Purple indulges your desire to mess around in your imagination. Dreaming of what could be. Dreaming of what if. Purple is at the edges of the seen and the unseen. Purple invites magicians and fortune-tellers to the party.

To broaden and contact my own relationship with and sense of purple I did an alliteration exercise. That is, I paired *purple* with other *p*-starting words to stimulate my imagination and memory of purple. Purple potato peels, purple people pleasers, purple princes planting passionate plums, purple picnic parties, purple penguin playmates, purple pointillist paintings, purple purse painter, purple plants please...

A chorus of purples

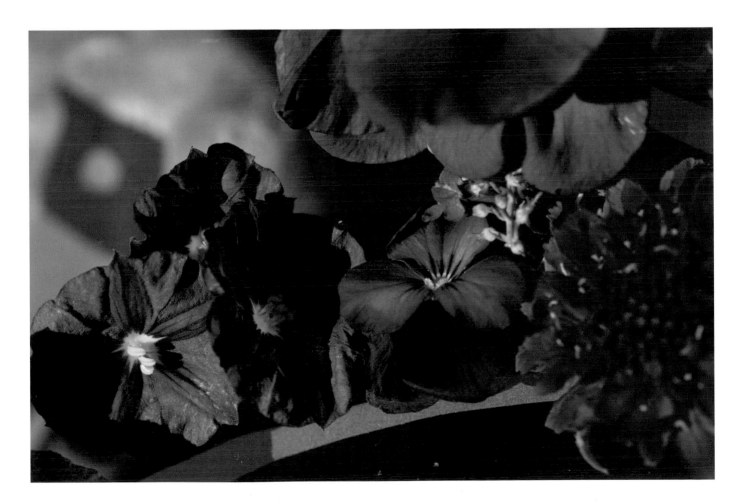

Purple is as useful to a gardener as it is to a painter on canvas, for purple is great as an underplanting to brighter colors. It makes them stand out. As yellow is a painter's color for brightening shadow and lifting colors up, purple makes colors stand out. Purple is a great backup color.

If you follow a purple brick road, where does it lead you? I found February violets alongside the path, reminding me once again, yes, of my mom. She was born in February, so her birthstone is amethyst. Her birth flower, violet. Spring violets are so easy to come by for the garden. Seeding nicely between stepping-stones and crevices, they make a carpet pathway for Persephone to leave her winter root-strewn abode in the underworld to return once again with the first flush of flowers. I can imagine that it is the scent of violets that awakened her. What is on your purple path?

Inviting purple to dinner

TRY THIS: Pick Some Purple Words

Make a list pairing a few words up with *purple* just as an investigation into the purple region of your imagination. Now imagine pairing these ideas with purple-flowering or purple-leaved plants. Purple veins in leaves are agents of mystery. They have that quality of drawing you inward.

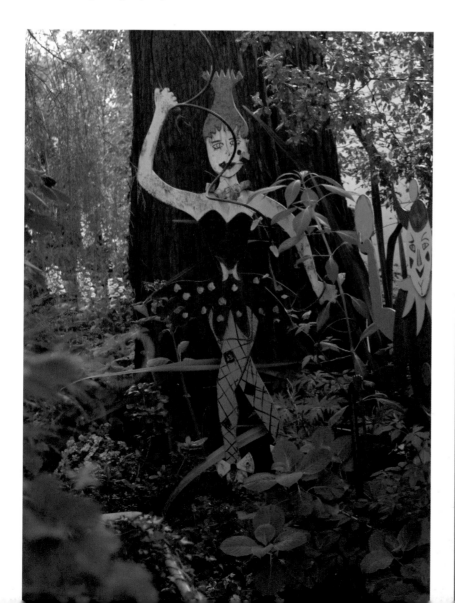

LEFT Yoo-hoo! A goddess on the purple path

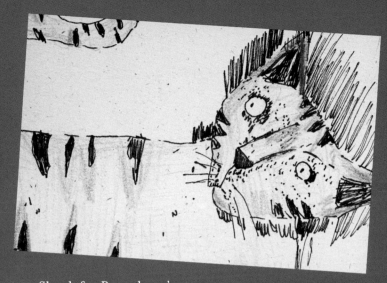

ABOVE Sketch for Persephone's cat

BELOW Connecting plants to hardscape: magic wand of color gardens

Persephone tile with solanum flowers

TRY THIS: Draw Persephone in Purple

Persephone is a goddess of the garden tracing an annual cycle, wintering over in the purple realms of the underworld to reemerge in spring along with the violets. Draw Persephone in a color palette of purples. Do you have a mystical side that you'd like to explore under the wings of a purple garden goddess?

In what way do you link the seasonal cycles of the garden to purple? Where are the shadows in your garden? Is purple whispering secrets on the undersides of leaves? How do the shadows work to hold up what is light?

Orange—Bold as Gold

Writing notebook in hand, I often hop up onto a bar stool to eat at the counter of one of the many local great restaurants. Too often my nose goes "ugh!" as I watch the bartender cut one of those cute curly-tailed orange rind squizzels to plop into an ice-shaken cool clear martini. Even a sliver of orange rind releases a broad spray of orange zest into the air. I'm allergic to oranges. Even the smell makes me nauseous.

Of all the colors, the one that consultation clients consistently don't like is orange.

Orange brings a powerful response. Early on a gardener friend ran into me at the nursery and said, "I drove by the front of your house, Keeyla . . . Why did you put orange and purple together? I think that is just so ugly!" I raised my eyebrows at her orange-and-purple panic attack. I calmed her nerves by drawing her attention to a flower that had already put orange and purple together, releasing myself from the grave responsibility for the alarming color combination. "Oh," she calmed down. "Well, it looks okay there, but in your garden . . . " "Orange and purple, Sharon," I consoled. "Look—it's a great color combination; at least this flower thinks so."

Orange and purple are indeed a great color combination—especially if you're drawn to strong contrasts.

Getting back to the restaurant counter, orange for me is at the nexus of a personal contradiction. As one who loves to eat, I hate oranges. They make me ill. As one who loves to garden, I

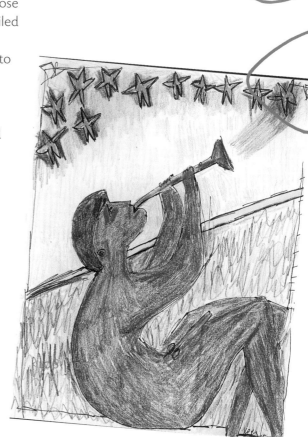

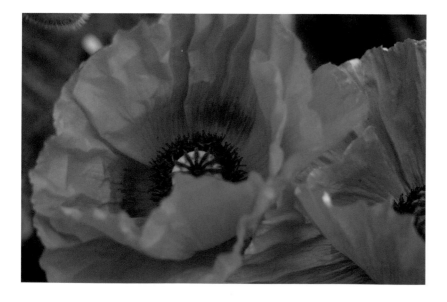

ABOVE Trumpeting orange to the heavens

LEFT Oriental poppies giving permission to make orange a color star

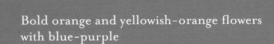

Bold orange and yellowish-orange flowers
with blue-purple

TRY THIS: Make Orange Color Combos

What colors do you like with orange? Make three
sets of color combinations that you like with orange.
By the way, that's a great color combination you've
just made. Almost any color goes well with orange.

Doodling in orange and blue

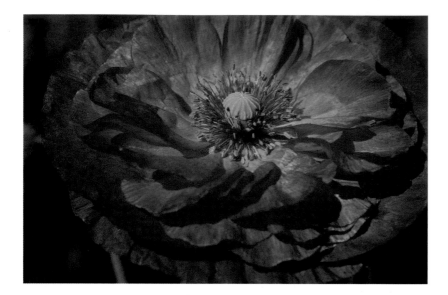

Shirley poppy giving permission
to put orange with yellow and green

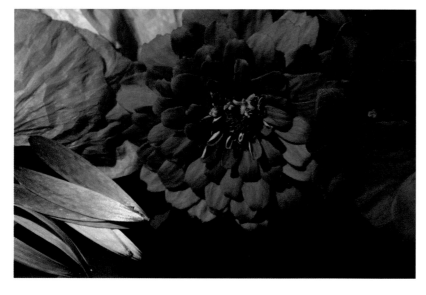

Orange color range with zinnia
at the center

love orange. Orange offers that special adventure of versatility. Orange
can be very modern. Orange can be that comic book blast of "pow!"
It can be a sublime chorus of the devoted, standing at the shore at
sunset, receiving the day's last rays. Orange is an orangutan of a color,
swinging from the pot of gold at the end of the rainbow to the edgy
explorations of the artistically inclined.

Orange is a firm, round, edible color. A reliable worker in the
garden. Orange has a happy family of harmonious hues and is a bold
avatar as a contrast. Orange is a great abstract color. Orange makes
its way across many expressive canvases. Orange sticks out from the

Diascia and calibrachoa hokey-pokeying

landscape in general since it's a strong contrast to two major natural landscape colors: green and blue. Green lawn and foliage, blue sky and reflecting water. You couldn't ask for a better color stage for orange. Orange is a show stopper!

Flowers give all the permission we need to be colorful. But in places where the sun shines hottest, it seems that people more easily gravitate to bright colors and lively patterns. I have one more orange story. This time there is no plane hopping. It's smooth sailing to Catalina Island, two humpback-whale-shaped pieces of land about twenty-two miles from the California coast—as the song goes: "Santa Catalina, the island of romance, romance, romance, romance." How did a drab scruffy landscape of coastal scrub inspire a song of romance? I really couldn't see, as the captain's boat pulled into the isthmus harbor. Not romantic by any stretch of the imagination. It wasn't until we cruised over to Avalon harbor and moored in the bay facing back to land, where we could walk off the boat and wander

over to the tall round casino at the end of the harbor, that I got it. This place is influenced by Mexico. That's where the romance comes from on Catalina.

Images of brightly feathered birds, castanet-clacking dancers, large-bosomed flowers, and striped-winged angelfish shout out bright colors from glazed tiles produced in the island's own ceramics factory. While the clay might be local, the images are from over the border, down Mexico way. However, there is something special in Catalina: one orange note, one orange natural element that is the exact same orange as the orange decorating the tiles. Not on land. Not in the air. But yes! Walking along the swooping promenade embracing the harbor, ending at the grand casino, if you look down into the cool water, you will find a bright bijou of the Pacific swimming—a brilliant orange fish. A grand casino, brightly colored tiles, orange fish, snow cones, bobbing holiday boats in the sun-sparkling harbor, that's romantic!

Before bidding orange adieu and embarking on a tour of our last secondary color, orange says to offer you some falling leaves to contemplate. Orange is a primary color that reminds us of the seasonal change of the garden from summer to fall. Pumpkin patches, persimmons ripening beneath orange-tinged leaves, all are avatars of orange's place on fall's color palette.

Green—Inside the Emerald Garden

Green is the last color star on Keeyla's color triangle journey.

Between the entry gate and the front door lies the Emerald Garden of my mentor, the great garden wizard Louie. A pool surrounded by "leafy dragons," giant gunneras, aurelias, horsetails, and papyrus. A garden Nile oasis. Louie was a gardener ahead of his time. Running an architectural business out of his house, he never let a house design escape without having a garden design to go with it. As the family babysitter, I watched over his shoulder as he worked on designing many buildings and gardens. In the canyon hills, decaying mansions of fading Hollywood stars were in the process of being torn down to be replaced by subdivisions. I tagged along with Louie as he hauled out quantities of bulldozed ornaments from these mansions. The Emerald Garden became home to these orphaned ornaments.

It's from inside the Emerald Garden that I learned about the invasive habits of some plants. Currently, horsetails are experiencing great popularity. Don't fool yourself. You can get too much of a good thing. Following my childhood experience with these galloping plants, I've warned many a neighbor and customer about safe planting

Greens in an experimental composition

TRY THIS: Go on a Garden Date with Green

Notice all the leaves you see in the garden. Take time to marvel at the shades of green in these leaves. Greet these leaves with gratitude—in this case, gratitude for shape. Copy or trace several of the leaf shapes. Now use these leaf shapes to make a drawing for garden ornaments.

TOP Umbrella-shaped greens

ABOVE Leaf-bedecked garden figure

LEFT Shades of green in contrasting shapes

procedures for horsetails. They need to be contained. My look-alike emerald garden that I planted at my parents' entryway rode off like a team of horses to return my parents' newly paved driveway to the era of dinosaur vegetation. Horsetails, one of the most ancient plants, I discovered, likes to run rampant. If there isn't a crack to come up in, it will make one.

In spite of this early horticultural catastrophe regarding the habits of equisetums, I learned much of value from my mentor Louie. Planting a green oasis between the outer world of the street and the inner world of the house can make for a soothing passageway between the two worlds. Louie also laid large stepping-stones in front of my eight-year-old feet. During the time I babysat for his children, he turned his living room into a studio for making sculpture. Soon his living room became a garden—only there were no plants, only sculpture. Most of the works were made from salvaged wood that was joined together and painted. Sculpture made Louie very Zen. He used only black and white paint. His palette of wood tones—black, white, and green—fit with his designs of buildings and gardens. I saw how many elements can come together where the whole is more than the sum of the parts; making a whole space like a garden and a building a work of art.

My mentor Louie was always up for a party. The foliage in his Emerald Garden, starting with the large umbrella plant foliage, provided a parade of costume ideas for garden fashions. In the Emerald Garden, the color green ruled. No flowers were ever in sight. What distinguished one plant from another was the shape and texture of the leaves. The wealth of this garden was its bounty of leaves. Leaf shapes provide inspiration for garden fashion, garden sculpture, garden ornamentation, garden get-ups. While you may not want plants to be invasive in your garden, let leaf shapes invade your design palette.

I liked how my mentor Louie's studio faced his garden. Growing a green thumb requires spending time with plants. Even looking at plants through a window of the house keeps you in constant contact. Caring for plants is the best way to grow a green thumb.

Here's a silly little story about green. Because I work with plants so much—half the time with gloves on, half the time with gloves off—I don't polish my nails. Nail polish would never last. Not very practical. If my hands aren't in dirt, they're in clay or paint or water. Dang! I'd like to polish my thumb green. I'm proud of my green thumb. I do polish my toenails, though, and I like to polish my big toe green. I have a green toe.

Green also suggests environmental responsibility. Setting garden

ABOVE Yellowy greens meet bluey greens

LEFT Swimming in a sea of greens

goals to be more green is not only admirable, it's necessary. In my garden I stay away from pesticides and chemicals in general. I've attended several seminars on composting and am especially intrigued by worm juice. One client poured worm juice on a new planting and it doubled in size overnight. I'd planted the same vegetables in my own garden and they looked like tortoises next to her hares.

One of my annual green actions is to give the garden a boot camp–style haircut in the fall. Get rid of all the year's tattered and torn greens by cutting them down and tossing them on the compost heap. This will make plenty of space for next year's greens to sparkle and shine.

TRY THIS: Adopt Green Gardening Practices

Take an accounting of your gardening practices. What are the ways you are already green? Are there some new techniques that you've heard of or read about that you'd like to try out?

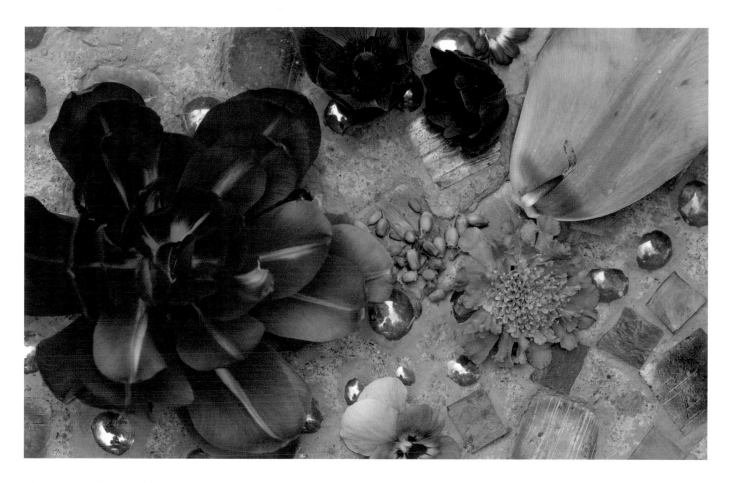

N-yummy colors on the
red-purple-blue leg

Using Harmonic Clusters

I call the legs between the six color stars on my color triangle harmonic clusters. There are six harmonic clusters: blue-purple, purple-red, red-orange, orange-yellow, yellow-green, and green-blue. These harmonic clusters situated along the pathways of the color triangle between the bright color stars offer the real—as my beachcomber Uncle Art used to say—n-yumm n-yumm n-yumm of the color palette. Each of these legs of your color journey between two color points is delicious.

Have you noticed that each of the color stars has two harmonic clusters related to it, one on either side?

- ❀ Blue has blue-purple and blue-green.
- ❀ Red has red-purple and red-orange.
- ❀ Yellow has yellow-green and yellow-orange.
- ❀ Purple has blue-purple and red-purple.
- ❀ Orange has yellow-orange and red-orange.
- ❀ Green has blue-green and yellow-green.

It's another color hokey-pokey dance of look to the left, look to the right of your seed color. A very simple way to come up with a color palette is to first select one of the color points, then one of the harmonic clusters next to it, then a contrasting color point, and then one of the harmonic clusters next to that color. This will make an adventurous, lively, and beautiful color group to work with.

ABOVE AND FAR RIGHT Yum-yum shades of crème brûlée, surrounded by daffodils

More Principles: Shades and Hue

All harmonic clusters are beautiful color groups. They are the hues of a color as it stretches toward another color. They are the children of the color stars as they pair with each other. You can make a lighter shade of any color by adding white, a darker shade by adding black. This is an arena to mess around in with color. I love all the delicious shades of lipstick sherbets found between orange and red as you add white. Salmony, peachy colors are my favorites. Where do you find your favorite hues of a color parent?

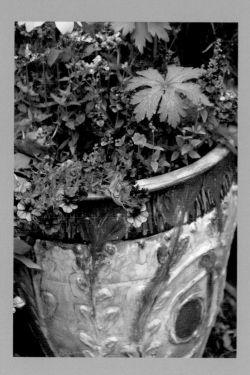

Purple-red diascia and purple
calibrachoa in a potted color bouquet

TRY THIS: Make
a Color Bouquet

Make a bouquet of colors from each
color leg or harmonic cluster. Be
methodical. Start with the blue-purple
cluster, then purple-red, red-orange,
orange-yellow, yellow-green, and green-
blue. Try using a contrasting color for
the vase.

TRY THIS: Make Cluster Desserts or Salads

If you don't want to make bouquets to practice your color harmonics, make desserts or salads from each cluster. Give your family and friends a laugh and have your nails done in an array of colors from a cluster. Be creative in how you practice with the harmonic clusters.

RIGHT Colorful woman contemplating carrots

BELOW Color cluster salads

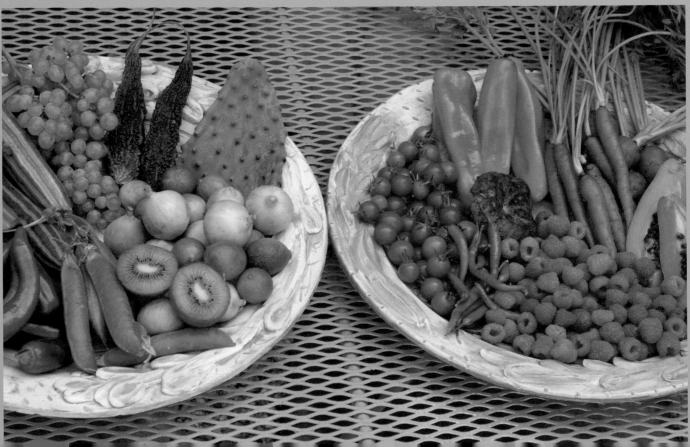

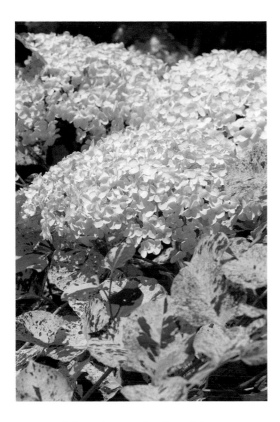

ABOVE A favorite combo for white:
garden-leaf green

BELOW White rose hugging a sculpture

Let's look now briefly at white, black, and some other footnote colors used to lighten or darken shades of the six color stars.

White—A Bright Star That Can Steal the Show

Seated in front of my demonstration table loaded with colorful plants at a local bookstore, wobbly on her Alice-in-Wonderland heels, a very small woman dressed from head to toe in lawn-flamingo pink got to her feet and raised her voice along with a braceleted arm waving an imaginary flag. "What about white? Don't you like white?"

A legitimate question for me. It's true that, on the whole, I stay away from white unless it is my starting color. White creates the loathsome blotch. What you don't want with color is blotch. White, being so bright, can stick out like a flag of surrender. Surrendering all your color efforts for naught. White can be that screechitty chalkboard note that sticks out like a sore thumb. I think you catch my drift.

Here's another drift to catch from a florist who is loyal to the cause of white. A woman rushed up to the counter of a coolly decored Japanese restaurant where I was lunching, inquiring if they had any of their prepared bento box lunches left. They didn't, so she ordered a meal to go. White Rabbit late, looking at her watch, she was preparing to dash back out of the restaurant while the kitchen prepared her meal until she caught the drift of the conversation I was having with the gardener who just happened to work at the restaurant. Sarah, the server, was telling me how for many summers while a neighbor went to Paris, she would water and harvest the flowers of the neighbor's dahlia obsession. Two thousand dahlias a year, I think is what caught the White Rabbit lady's ear. Sarah and I were talking about orange in the garden. Bemoaning that so many of the dahlias were in shades of orange, Sarah said that with having to tend to so much orange, she found herself coming to dislike the color. The bento box luncher stopped in her tracks to agree. Shaking her head, giving orange a definite "no" vote. Since I'm a big fan of orange, I spoke up for my color team.

"I'm a florist," the White Rabbit lady offered. Then she said, "Bright colors are so popular, but what I like is white. My garden is all white. I want the peace it brings. I can't even imagine bringing in any shade of orange. Not even peach. Although I did talk my sister, who loves orange, into using peach when I redid her garden." Then she became adamant. "Yes, I am loyal to white. My house is green and my garden is white." I saluted her loyalty. To my eye, the best use of white

Streaming white, yellow,
lavender, green

TRY THIS: Find Fabric Patterns with White

Take yourself to a fabric store. You will find a lot of white in many of the lengths of rolled-up yardage. Study how white is used in the color patterns in cloth. Collect a few swatches of any patterns with white that speak to you. This patterning will be useful to imagine transposing onto a space in your garden.

is all white with a definite shade of garden leaf green behind it. Just like the florist's house and garden arrangement.

But then I definitely like white with black. I like white especially especially with bronze. I think white is lovely and lively with yellow. And it's a natural with blue. White makes a superb palette with cream yellow, lavender, lilac, and apricot. I have never thought to put white with the orange that these two color "haters" (that's hip-hop lingo) are so against. Haters are spoilers. As I tried to bring the florist and Sarah back around to orange, they drew me back over to white. By the time we finished this color tug o' war, the lady's custom bento box had arrived. Lunch bag in hand, she made a Mad Hatter, White Rabbit, "I'm late, I'm late, for a very important date" dash from the dim of the restaurant to the blast of sunshine outdoors.

White with a hint of a tinge of a blush,
with raindrops and gnat

White paired with black

I keep white apart, but that's me. White works well with any of the other colors. When using white I select it as either my starting color or my primary contrast. White works best when it is drawn through the whole space, very balanced on either side of a focal point. It can also work as the "lead singer" focal point. This keeps it from becoming the tail-that-wags-the-dog blotch. In any event, if you don't pay attention to the whereabouts of white as one of the partners in the primary color dancing duo of harmony and contrast, it can create the enemy of garden color—blotch and splotch, breaking down your intention to

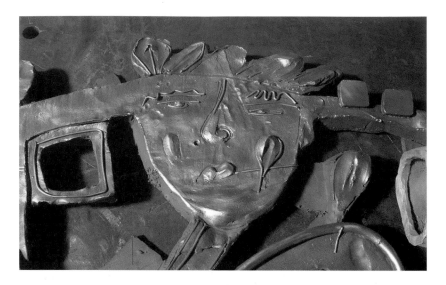

LEFT Silver, a special and unique color in the garden

ABOVE Silver foliage, which shows up like white

BOTTOM LEFT Brown-and-caramel plant palette

Trying out unusual combos in a planter

have the eye flow. White can make a bright shock that unbalances the whole show. It makes for a strong contrast, but it needs to be placed in the space with focus and precision.

Black and Silver, Bronze and Brown

Just a note on black and silver, bronze and brown. Each of these colors has many representatives in the plant world. You can find dramatic flower characters—as well as a bounty of leaves and fronds—in black and browns. Of course, the whole of the drought-tolerant world of plants is shaded in gray. I'm just making a nod to these colors, inviting you to follow the same principles in working with them in your garden. Black, bronze, and grays are especially celebrated as plant colors that work well in contemporary gardens along with glass, concrete, and steel architecture. As these colors are the shades of grassy foliage, they are among my favorites to combine with sculpture in the garden. Sculptures just love to jack-rabbit out of grasses.

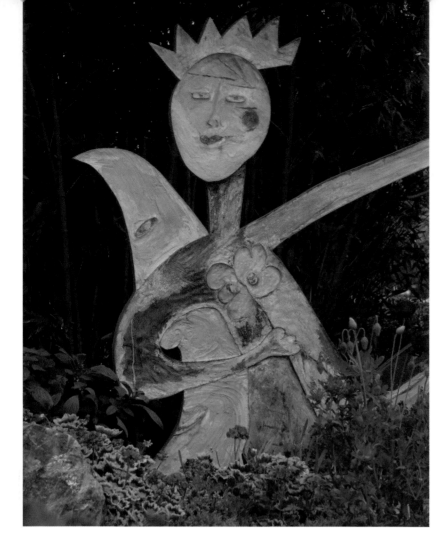

Color Palettes for Paradise

I hope that by the time you've gotten to this page you've dated, kissed, and gone on an adventure with each of the color stars on the color triangle. With the color triangle as a guide, it's easy to determine all sorts of color palettes for any garden situation.

Starting with the color equation of harmony and contrast, these are the steps to follow to select a color palette:

1. Start with one color. This is the seed color for your palette. Be loyal to that color.

2. Select a harmonious cluster to go with your seed color. Do the hokey-pokey color dance of looking to the right or to the left of the seed color to choose a harmonic chord. You can think of your seed color as your lead singer and the harmonic chord as your backup singers. The backup chord is either on the hot side of the seed color or on the cool side of the seed color. For example, if you've selected

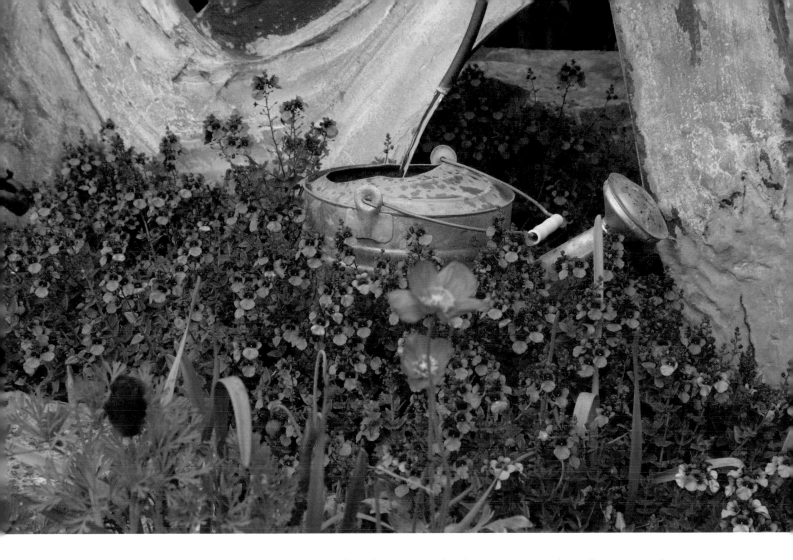

Matching plants to painted objects

yellow for your seed color, you can use the yellow-orange harmonic or the yellow-green harmonic for your backup color cluster. Yellow-orange is warmer than yellow-green. (Take note: orange has warm colors on either side. You can cool any of these colors down by working in a shade of a color that has a touch of black mixed into it.)

3. Select a contrasting color. The harmony seed color and the contrast color are the two main players of your color palette. The greater the difference between your harmony seed color and your contrast color, the more dynamic the color palette. The three primary colors are in the greatest contrast to each other, so pairing any two of these will make a dramatic color relationship. The secondary colors are also in great contrast to each other. Any two of these colors will also make a dynamic color duo.

4. Select a backup chord for the contrast color. Just as with the seed color, use the hokey-pokey method of looking to the right and to the left to determine if you're going to use a warm hue of the

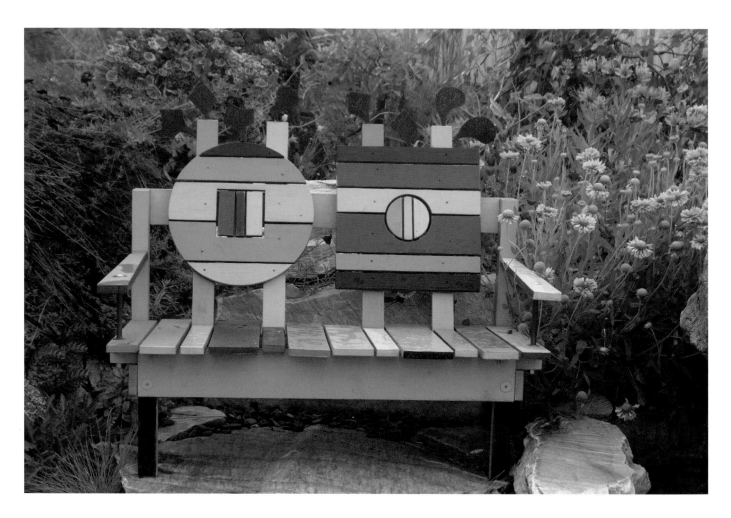

contrast color or a cooler hue of the contrast color. So, for example, I'm going to use yellow as my seed color, pair it with cooler yellow-green, then contrast it with purple and use the warmer chord of purple-red as the backup chord for purple. This gives me a dynamic color palette.

5. After you have selected your seed color and your contrast color, green is most likely still going to be a factor you need to account for. Most of the foliage in the garden is green. Select the green you want to work with. Is the green harmonious with your seed color or is it closer to the contrasting color? With these colors you are good to go. Example: With my yellow/purple palette, my backup color chord is the green-yellow harmonic, so for my green I'm going to select a green that is yellow in hue.

ABOVE Bench painted to go with plants

RIGHT Palette of harmonious flower colors and contrasting foliage

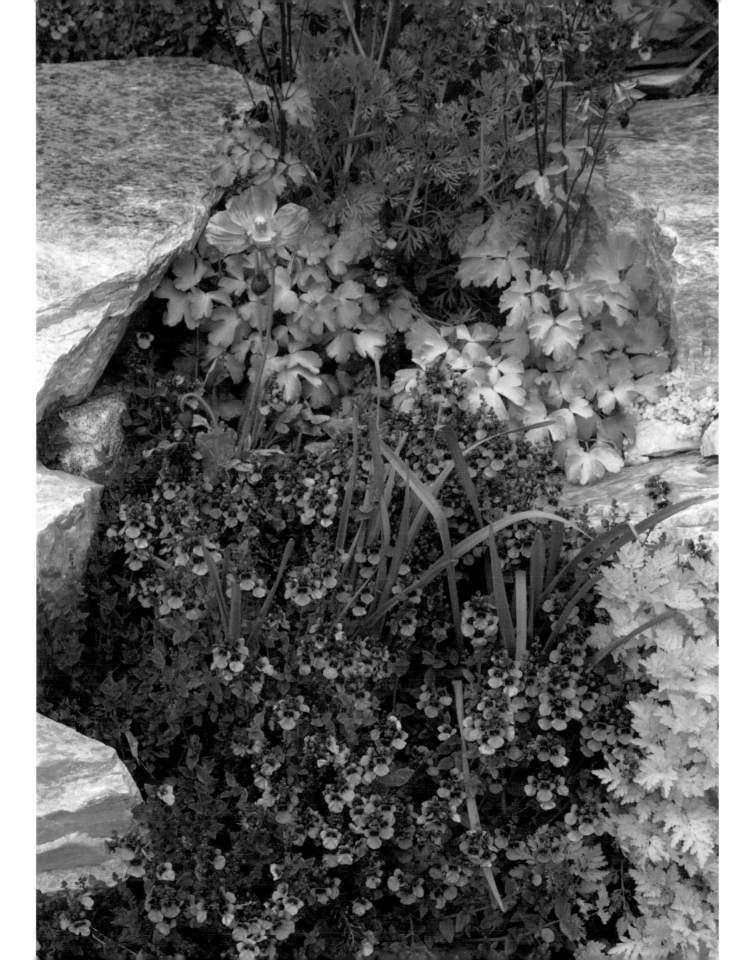

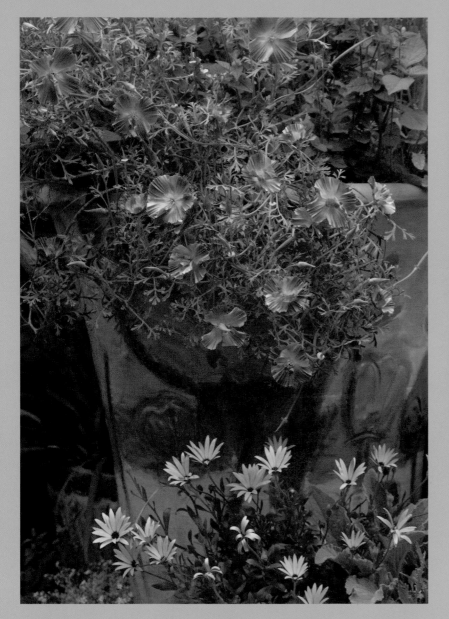

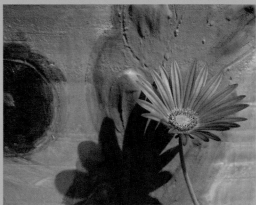

TOP N-yummy creamy yellow, pink, and blue

ABOVE A plant color chosen to match an object color

LEFT Colorful plants + colorful objects = a garden painting

TRY THIS: Apply Keeyla's Color Triangle

Use your color triangle to make sample color palettes. Place a drawing of your color triangle in front of you. Now follow the steps outlined above to make three simple color palettes.

There is a universe of color palettes to discover, made up from the hues and shades of your primary and secondary color stars. Play with color combinations that you like, staying grounded by finding their "parents" on the color triangle.

6. If you want to broaden your palette and include more colors, start by selecting more colors that are harmonious but don't upstage your seed color. Try adding another color that is harmonious with your seed color, then add another chord of backup colors for that color. This makes for a full palette. You can keep going this way to add more colors, but remember that fewer colors work well and keep things simpler when purchasing plants.

7. Expanding your color selections on the harmony side of the palette and keeping the contrast at one color plus the backup cluster will keep things simple, but if you want a very contrast-y garden, try working with all contrasting colors. Use your triangle to find contrasting pairs.

These steps are guidelines to help support and empower you with color. I discovered these guidelines while teaching classes. They are starting points. If you find another method of combining colors, go for it. Once you get started, your intuition might take over. Let that be your guide. You will start to recognize the presence of your intuition by a feeling of connection to flow or some other sensation by which your intuition speaks to you. Have fun, for just like in the hokey-pokey color dance, that's what it's all about.

Now that you have your color palettes, let's create a garden paradise.

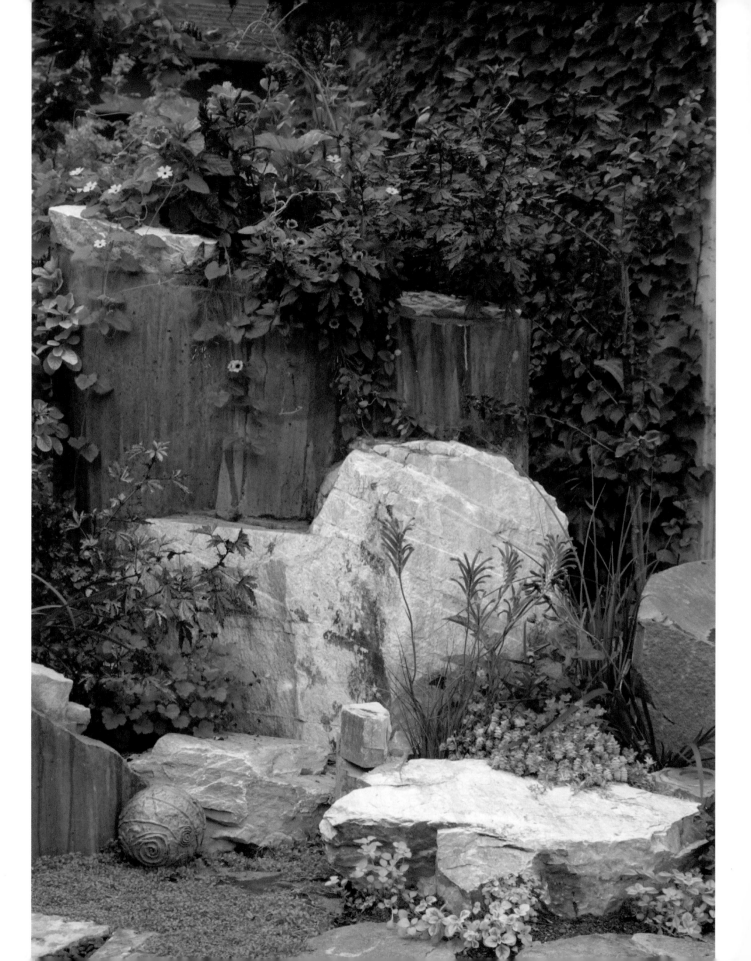

PART TWO
Building Color Gardens

ABOVE Constructing the hardscape . . .

LEFT . . . and then planting it!

As with color, I like to break garden design into steps. Once you have your color palette, the next step is to locate where you want to put your color to work.

Framing Your Working Space Like a Photograph

To get color to do its job, you need to designate a location and a boundary for it to work in. I call this the working space. This space is as important to a gardener as a canvas is to a painter. A camera will help you find this space and make it as special as a painting by "framing" it.

For the origins of this idea, we have to go back to my childhood. Runnymead Street blasted white heat from one end to the other. With only evenly laid-out square plots of lawn edged with concrete sidewalks and front steps leading to doorways of evenly spaced, small, mostly wood-sided homes, there was nothing to interface with the sun. Both ends of the street caught rolling balls of tumbleweed against cyclone fences. One fence kept us neighborhood kids off the San Fernando Valley freeway; the other off the school playground.

It didn't take my grandfather's camera, bouncing off his sheer short-sleeved cotton shirts, to warn me of the red fire ants crossing the sidewalk where I was sitting. I'd been stung before. I was onto these ants. What Pappy brought to this scene was an eagle's eye. I'd watch him take up his camera, unsnap the worn leather casing, and hold the silver-and-black-metal body up to his eye. Down the street. Nothing. Up the street. Nothing. Then his eye focused on the flowers growing next to where I was seated, while I held a stick to redirect the path of the ants. Salmon. His eye saw salmon coral. Snap—like a fish taking salmon-egg bait, he got what he wanted. A row of slender, flamingo-necked coral bells. A Sunday painter, Pappy always carried square canvases under his arm, the background inevitably painted sky blue to frame his Sunday flower.

Like my Uncle Art, Pappy was in the motion picture business, having left one coast for the orange groves of California, where

LEFT Framing the working space

RIGHT Planting color from edge
to edge of the frame

Columbia Studios had set up shop. As head of the film processing labs, he was used to looking at things through frames. Film frames were his business. On Sundays, he was still looking at frames, but they were almost always filled with blossoming flowers. On Runnymead Street, my mom was the only one to plant seed starts that came into bloom. Everyone else cultivated the glare of the sun with parched lawns, and needly, prickly shrubs that were drooping, exhausted from the heat. I knew, because I'd sneak behind them during games of hide and seek.

My eye, like Pappy's, learned to seek out the flowers, noticing subtleties in the shades of color, the shape, or the arch of the neck of a plant. Even before planting daffodils with my mother, I remember studying the poor line of coral bells—their basal-leaf petticoats all dried out underneath, their rumpled-edged leaves struggling to stay green as dancers' skirts. Still, their sad skirts didn't seem to interfere with the very reliable annual entry of a cancan row of dancing flowers. Salmon is the first color I remember seeing. It's still my favorite color, except in the form of biting fire ants.

Now that we've traveled down and up the color triangle, making our color seed selection, reenter my muse, Emerald, to lead the way. Now she's dressed as a ringmaster. "Wait a minute, Emerald. Watch that whip!" It's time to take our color characters and put them up on a stage. Let's put those color stars to work.

Pappy now steps into the ring, holding up his camera in a victory salute. The camera will be our starting tool on the second part of our color journey. For the moment, lay down your shovels, gardeners, and take up your cameras. Pappy is going to show us that a frame is a frame is a frame is a frame. Okay, Pappy, do your tricks.

A camera is a tool that brings focus to the design process. Each selected color palette is going to be put to work inside a selected, focused, framed space. In the design process, the first step is selecting your working space.

The Camera as Our Tool

The photographer is always working with a frame as a definite boundary; the frame contains what is to be seen and shared. Taking a hint, we can similarly use the camera as a tool in defining and framing our working space. When I first got published in garden magazines, I'd watch the photographers when they'd come into the garden to take the pictures. In the same way as I'd follow my grandfather's eye with his camera, I'd watch the magazine photographers seek out each garden picture. Once they got it, they'd set up their tripod to wait for the

TRY THIS: Look for Pictures in Your Garden

Go out with your camera and take a look with new eyes. Go out when the light is even. It's easier to take photos if there are not a lot of shadows. Mornings and evenings are the best times for even light. Take photos in such a way as to frame your working space.

Locate the spaces that you want to frame with your camera. Stand at each of the entries going into and out of your house. Take pictures from all the windows that look out into the garden. Take pictures from inside the garden looking back at the house.

These are all images to revisit with a new eye to color. If you have Photoshop, play around with your images to test out one of your seed colors in each space you have photographed. Print your pictures and put them in your color journal. We will return to these photos later to place focal features inside each garden picture.

Take your camera into the garden

light to be just right to fully capture the whole scene within the picture frame. Bounded in this way, pictures of my garden seem to speak volumes. "Quiet out there!" My garden is full of talking pictures. Well, what do you expect? I'm the granddaughter of a motion picture maker whose Sunday passions were gardening and painting.

The reason my gardens are so photogenic is that they are set up as a series of pictures. Each space is organized with strong focal points that bring the eye to a stop. Once the eye stops at a particular spot, everything is ordered around that spot. While this is a basic principle in painting composition, it works well for gardens, too. As with a painting, you have a frame. That is the boundary of your working space, and you have to work with what is inside of that space. You can link each framed space to a selected garden color palette. Each frame can feature the color seed of your palette.

When I began to take photographs in the garden, I noticed that even when the garden was in full bloom and beautiful to my eye, it didn't read well as a picture. Hmm . . . what's that about? In popped my muse, Emerald. "Your picture needs focus. Think of a painting or a play," she said. I found that by putting an object inside of the picture, creating a relationship between the design elements—something for the plants to interact with—I was able to create a more photogenic garden setting.

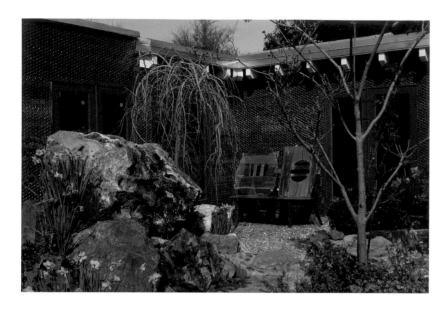

Dividing the Garden into Zones

As a professional designer, I start garden designs with a conceptual layout drawing. I use this drawing to divide the garden into zones. Each zone describes a space in the garden. Function, theme, location, color palette, plants, hardscape materials, and focal features are all part of each zone description. I also use a form to describe and design garden spaces by zones:

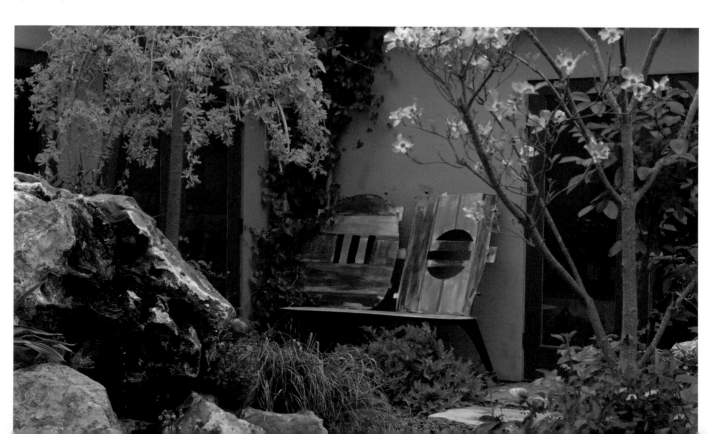

Red as seed color for one zone

TRY THIS: Describe Your Garden Zones

Make a zone notebook or designate pages in your color journal for your garden zone map. Walk around your garden describing each space as a zone. For example, you might start with the front entry zone, the curbside zone, the kitchen door zone, the patio zone, and so on. Make a layout drawing of your total garden area. Define the boundaries for each garden zone. Number each zone, title it, describe the function of the space, then give each zone a seed color.

Garden zone worksheet

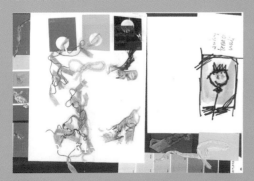

WORKSHEET

Zone name:

Color palette:

Function:

Focal feature:

Design motif:

Materials:

Plants:

I have a definite color map of my garden and of all the gardens I work on. This makes keeping track of each area much simpler. It helps you discipline yourself when purchasing plants and objects for your garden. Having a color scheme brings focus to each zone; it supports you in making clear decisions about what will be included and excluded from that area. In my garden, for instance, I have the front sunset shades garden and the turquoise pear fountain in the edible garden; then there's the red garden, where there's a large woman with a red watering hose fountain; the gold and pink garden, with a flying goddess; and finally, the yellow and purple meditation garden, and the gold and maroon red garden, home to a sculpted dress.

Gardener's Coloring Book: Outlining Spaces for Color

Before deciding how I will use color in a space, I see the design as a line drawing on a blank canvas—much like the outlines in a child's coloring book, the design gives me the shapes to be filled in with my color palette. Once the shapes and spaces are set in place, I make several copies of my "coloring book" drawing to test out different color palettes for that garden picture.

ABOVE Coloring-book outline for a garden area

BELOW Outline colored in

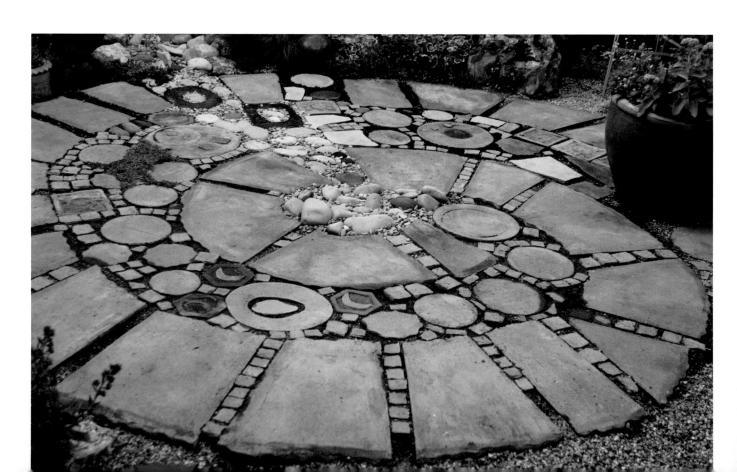

Outline drawing of a bench

TRY THIS: Make an Outline Drawing

Make an outline drawing of one of your framed working spaces. For example, you might want to design a bench setting. First, make an outline drawing of the bench. You could call in your color muse at that point for another version of the hokey-pokey design dance. Look to the right of the bench. Ask yourself, What do I want to put there? Look to the left of the bench. Ask yourself, What do I want to put there? Then, look to see what's behind the bench and what's in front of the bench. This way you design a complete space.

Once you have this complete space, you are ready to copy your line drawing and color it in, testing several different color palettes. Have fun with your coloring book! Scribbling outside the lines is a good thing here. It shows how color can move from one thing, one plant, or one object to another, by matching colors.

Color moving from plants to bench

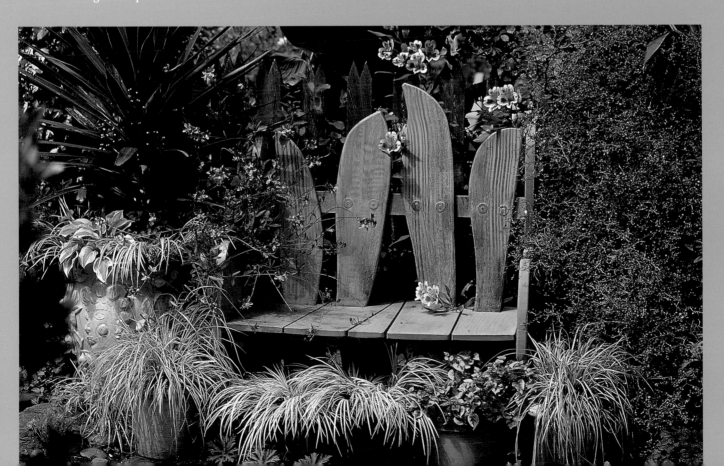

Color in the Plantscape-Hardscape Equation

Just as color has the harmony-contrast equation, garden design has the plantscape-hardscape equation. Garden design will always have two elements: plants, and everything else, which is the hardscape. The idea is to work one color palette between these two halves of the equation.

One way to get color to work on both sides of the plantscape-hardscape equation is to match colors. By matching colors, from one plant to another and one material to another, you can place color quite deliberately in the space. Start by matching your seed color to both plantscape and hardscape materials. This will give you the flexibility you need in order to place the color in both your plantscape and your hardscape as you build your complete garden picture. Matching colors gets the color to move within the space; one of my favorite uses of color matching is to create lines or streams of color.

Matching is also the easiest way to work with the existing color in your garden. Find one plant or hardscape feature in an area of the garden to designate as your seed color. Then as you add plants or hardscape features, use that color to extend into the space.

People are always surprised by how many color matches there are in my garden when they visit on open days. You, too, are invited to visit to see what's matching. This is part of creating a flow to the harmonious color palettes. I call them color dreams, for as color flows from one material to another and from one form, texture, or shape to another, it gives that feeling of fluidity that is more common in dreaming. You could make a painting and then a garden of matching colors titled "The Garden Dreaming." Make notes in your color journal about your garden's dreams.

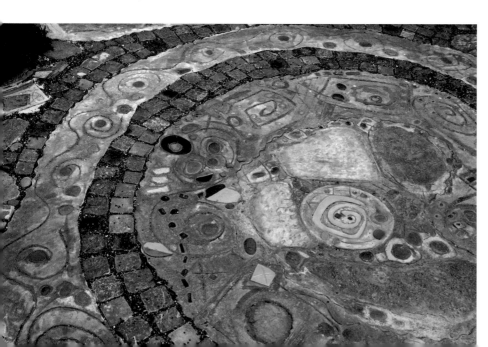

Making a garden patio with colors to match with plants

Matching plant to hardscape

TRY THIS: Match Colors

Take one color. It could be a seed color for a color palette. You might keep this color with you in the form of a colored paint chip. Match this color to a flower. Take one flower, then match the color of the flower to other flowers, then to leaves, fruits, bark, and so on. Continue to match your flower.

After matching your color to other plants, match it to hardscape materials. Matching your color to hardscape materials will give you new ideas. Match it to paint, rock, planters, wall materials, paving materials, and anything else you might bring into the garden.

Having an ingredients list of one color that spans both the plantscape and hardscape of your design equation is essential to your being able to work the color from edge to edge of your working space.

More fun with plant-hardscape matching

Plantscape-hardscape—get it together and get it on, commit to making your color relationships be ones of love, of enthusiasm, of connection, ones that work. To do this I ask these questions: What is the potential here for a garden picture? Very specifically, what is my seed color that I want to work between the plantscape and hardscape relationship?

Garden Tango: Color Dance

Wanting to make relationships with color is a primary motivator for me in being in the garden. Loving plants is a given, matchmaking is an obsession. What sets my work on the garden apart, at least at the start, is how I don't let anything into my design zone that, colorwise, is not part of my picture.

The traditional way of thinking about the color in a garden mostly has to do with the color of the plants' foliage, flowers, bark, stems, fruits, and berries. Not so for me. Everything that goes into a garden has color. I make a color palette for the whole working space, and everything is part of the selected color scheme. If as you go you find plants or objects or other materials you want in the space, then expand your color scheme and work with this new color in relationship to the already existing color palette.

The main color dance happening in a color-designed garden is between the hardscape materials and the plants. The sky comes in. The earth, too. But the main dance that you can set up deliberately is between our two tango partners: plants and the hard stuff. Extending colors by matching, carrying, or drawing a color through all the various plants and objects in a scene makes the color very present. It makes the color flow, seeming to just run, bounce, dance, or move in some other fashion between things. You are the choreographer, the designer of this color dance, as you select and place plants and objects in such a way that the color is in relationship between them.

As with selecting a color palette, my preference is to have the seed color be very present, with the harmonic palette as the backup and the contrast color to pick up, magnify, and draw out the other colors. There is no way around it—when you are working with this much focus on color and making decisions and relationships, you are being an artist in the garden. Take a bow. There are many ways to use and engage the colors that are on your color palette. Keep handy the image of the artist holding a palette of colors and standing before a blank canvas. You can find a postcard with this image. Many artists have drawn this scene. Wield your artist's paintbrush in the garden.

ABOVE Assembling a color palette
that dances

BELOW Carrying a color through
plants and objects

LEFT Garden dreamer trying out
color arrangements

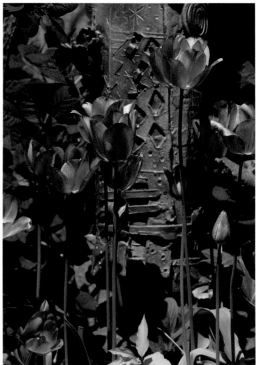

TRY THIS: Look at Paintings

Go on a date to look specifically at paintings.
Find several works of art that handle the same
basic color palette with very different ways of
using the paintbrush. Then try out various ways
of organizing your color inside your framed
working space by imagining and drawing,
painting, or arranging with plants what you
have gleaned from looking at the paintings. If
you are a very spontaneous type, you can have
all your ingredients lined up and then just have
a go at it and see what comes out.

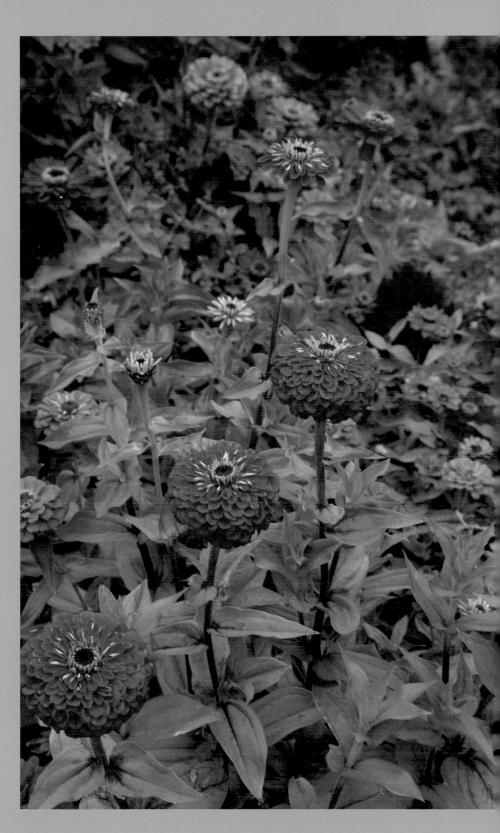

Painting with plants

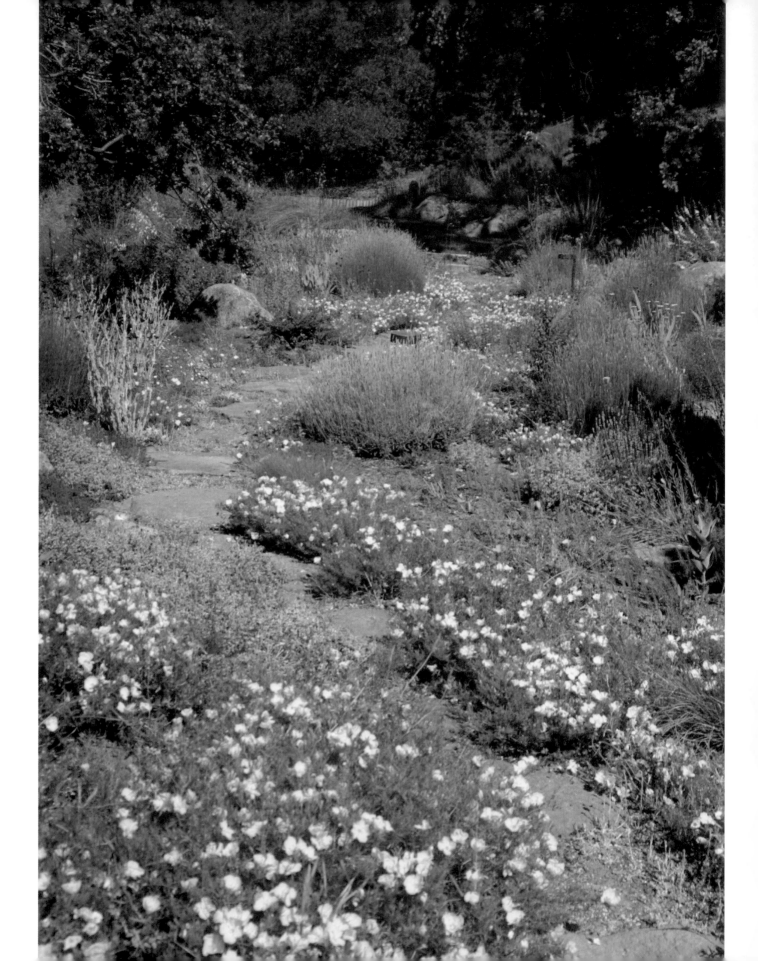

Blue in swaths and splotches

TRY THIS: Discover Your Way of Working with Color

Do you like dots of color? Do you like dabs, dashes, long streams, whole great continents of colors, like you find on maps? How do you like your color? Do you like to feel like it stays in one place, or do you like it to move? Look at several paintings and swatches of fabric. What is it that you like about the color in each instance?

LEFT Lots of yellow

Color Considerations: Quantity and Proportion

There are two big considerations with color: How much overall? How much of each?

You can have as many styles of working color in a space as there are gardeners. But to find how you want to use color in a space, I suggest taking time to study the paintings of an artist you love. If you squint your eyes when you look at a painting, you can see how the color is distributed across the canvas. If you were just to move the color onto another canvas without the lines or shapes, what would the color by itself look like? How much room does each color take up? Does a color travel all over the space or stay in one place? Is the color distributed evenly or erratically? Does the color seem to swim or dance? Or does the color stay very still? Is the color rhythmic in its distribution or is it in big separate clumps? Does the color in one part of the canvas relate to the color in another part of the canvas or are they very separate?

The key to looking at your garden space with an eye to color is making decisions about distributing the color through the space. How much of each color do you want? Where do you want the color to be? You get to decide, at least when you start out—as plants grow and reseed through the changes of each season, the colors will change as well.

I have two primary ways of using color. The first is making what I call glitter field paintings. This is my version of paradise on earth. I work this way both in the garden and on canvas. When I plant many leaves and petals in a very colorful setting, I love how the sky just showers the garden with color and light. This basically comes out of impressionist paintings, where color sparkles.

In this type of color usage, we can see several things. First, there is a lot of color. Second, color is distributed in small, even amounts across the whole field or working space. Finally, all the colors are "on" all at once—everything comes into bloom at the same time. With thousands of leaves along with thousands of petals on the plant side of the equation, I can extend these glitter-all-over scenes by having a very colorful hardscape over on the other half of the design equation.

The second way I like to work with color is by using a mostly two-toned, high-contrast color palette. This can be set very strongly by the hardscape color and supported by the plantings. You can start by selecting the plants by color and then build the hardscape—also by color—in which to plant the plants. This is how I went about my yellow garden. I knew I wanted yellow in the back area of the garden to brighten up a dark corner. After making a plant list by researching plants at the nursery, in local botanical gardens, in catalogs, and on trips, I then built and mostly colored the hardscape with paint. Each time a plant came into bloom mirroring the colors in the hardscape, it was if they were long-lost friends being reunited.

You can set up the hardscape to be mirrored by the colors of the plants, thus enlarging the area of a particular color or color group. Or you can have the plants be in contrast to the hardscape. It's the same as in our basic color relationship of harmony and contrast. The more the plants are the same color as and in harmony with the hardscape colors, the more harmonious the whole garden picture is. On the other hand, the more contrast between the hardscape and plantscape, the bolder the scene is. Any use of color can be dramatic.

To get the amount of color I need in order to create a garden picture, I almost always purchase at least three to twenty of each plant I am using, depending on the size of my working space. I hardly ever just purchase one of my selected plants unless I'm planting a container. You need to get enough of each plant selection to work the space. You always need to think of the plants as working from edge to edge of the space. The repetition and rhythmic layout of plants will enable you to work the whole space.

Contrasting red and yellows

Hardscape: The Stage for Your Color Stars

Color palette in hand, you are ready to paint the garden with your colors. Bravo! Thus begins the next phase of your adventure in colorland. First you will work the hardscape side of the plantscape-hardscape equation. The hardscape is the container, the vase for your floral display. The hardscape is the theatrical stage setting where your plants are going to show their stuff. To start creating your garden, you build the set out of the hardscape materials; plants come in afterward. Even if you have already selected your plants—by color, of course—you will not plant them until you have completed your hardscape.

For more on the stage concept, let's go back to my childhood for a moment. On Runnymead Street, when I'd get tired of redirecting fire-ant traffic, I'd sneak behind the corner of the house to watch the neighborhood band of boys play at being drunken pirates. I'd already found out that I'd best keep my distance when my brother and his

Giant planter as stage for color stars

TRY THIS: Make Your Own Stage

If you haven't just messed around in the garden or built a temporary construction outdoors, I recommend you do so. Making driftwood beach constructions is a way to loosen up on your path to making garden constructions. Go somewhere where you can play with materials. Set it up like a stage. Then put on a play! Let your hardscape be an invitation to your plants to show off their stuff.

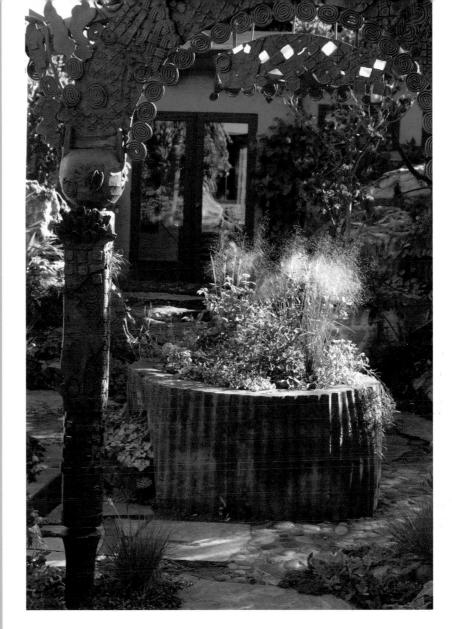

Theatrical props emphasizing the stage set

gang got drunk on boyhood. But these boys were up to something that interested me. There was one lonely tree at the end of Runnymead—not on the street, but in our backyard. This old walnut was the reason that our house was selected by the pirate band for their daily work. Every day, the boys would set up a stage for their ritual pirate initiations, hangman and walk the plank.

This is when I first observed that the garden is a perfect place to set up a stage. The boys had taken over a whole section of the garden. I'd watch as they would methodically first cobble together a prow for the pirate ship, place their cannons, erect a mast for a bedsheet sail, then set the stage for their daily rites to see who had the guts required to do a pirate's work. This is where the walnut tree came in. A sling of rope hung over the tree, an orange crate below, and then a plank,

protruding out into the summer wading pool, which was set over the sandbox and filled daily for the approving splash that passed each boy in the pirate test.

From these pirating boys I got lessons in garden construction. I also saw that the garden could be used to make fantasy and ritual settings right alongside my mom's flower beds and vegetable garden. The garden could have many stages, many plays, many pictures. My early garden stages were mostly for turtles. Digging out large ponds, crossing them with planks, I made my own type of garden stage and setting. Later I started making circus tents in the garden. I still like gardens that have a circus or carnival flavor to them.

Before working the color palette into the plantscape-hardscape equation of garden construction, I first organize each space of the garden. I follow a very simple composition practice of locating a strong focal feature inside a frame. Once I have the focal feature placed, the rest of the space is organized around it: the background, the foreground, and the left and right sides of the focal feature. It's like putting the star of the show on center stage or some other part of the stage. The stage is the frame or boundary of an area of the garden where you are going to work your color palette; it's the space that surrounds your central focal star. This is a physical layout that can be made with your hardscape materials. Plants, too, can make strong focal features, especially plants with sturdy architectural shapes.

When you frame an area of your garden as a stage is framed, you have your working space. Make it work. As a song in my workout class says, "Work it. Work it real good." For me as an artist, this is how I approach both the garden and a canvas. I want to unleash the potential of an area.

Focal Points to Organize Space

Just as with putting together a color palette, both my process and my recommendation is to have a starting point. With design, as with color, it's important to have a focus. You can call this starting point your home base. It's your seed. It's your grounding core. It's your root. For each area that I design in a garden, I always start with a feature placed at a focal point. That focal feature can be a planter, a bench, a sculpture, a rock, a specimen plant, or a built-up mound. It might be your front or back door. But it's some kind of feature that's strongly going to attract and focus your attention.

The next step is to decide how big a space this feature will be holding, or keeping your attention on. One feature can hold a whole

Focal feature and contrasting flowers

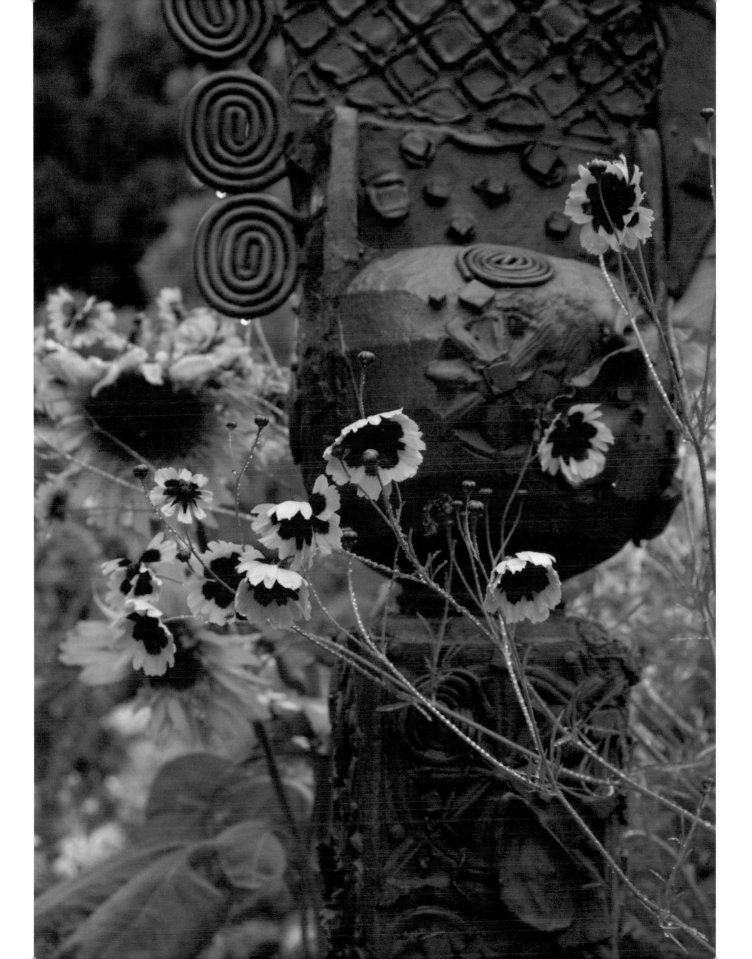

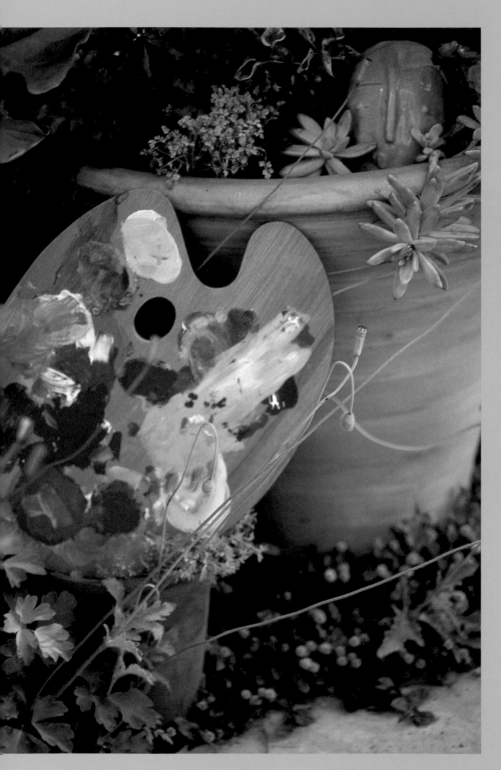

Artist in the garden

TRY THIS: Create a Painting

Imagine an artist dressed in a painter's smock, brush in hand, boomerang-shaped palette stuck on the other thumb, glistening globlets of paint squeezed out on the palette, standing before a canvas on an easel. Envision the artist holding a palette of colors made up of a harmonious seed cluster and a contrast color. Imagine yourself holding an artist's palette with one of your color palettes. While it's fun to imagine, it's more instructive to try this out.

Go into your garden and identify an area that you would like to work with. Then take an actual canvas or piece of artist's watercolor or drawing paper and gather the colors of one of your color palettes, the one you would like to apply to this area. Paints, crayons, pastels, colored pencils—all are good. Now you're ready to create a painting.

Apply the colors to your canvas or paper as if it were your garden space to see how you feel about these colors. Without thinking, apply the paint to the canvas, or watercolors to the paper, and see what you get. Do several. If you don't feel like trying this with paint, then try it at the table with food. Have a fork as one side of your boundary and a spoon as the other. This is your frame. Now with plates, glasses, and food, make a color painting.

TRY THIS: Draw the Space

The next assignment is to draw the space. So many people have the idea—set at some degree of firm, rigid, or absolute—that they can't draw. Just sweep those thoughts away or counter them with, "I'm not drawing, I'm just writing. I'm writing with lines." On a piece of paper with a pencil, make some lines. One set of lines, squiggles, scratchings can just be whatever. Whatever is always great when it comes to lines, squiggles, and scratches. Just keep doing it until you make a relationship with the space that you are working with.

Crayons to play with

space. A planter might hold a small space, while a large rock or a house or a great horizon will keep your attention on a large space. The key elements of my design process are the focal feature and the frame. The frame answers the question of how much space the feature holds and defines your working area for each color palette.

Designing with a focal point in mind makes me think that I'm creating a stage set with the focal feature being the star. If you imagine the space you're working with as a stage set with a star that you have your eye on, that can help you conceptualize the space. If the star is at center stage, then you have the space behind, in front, to the right, and to the left.

The reason I work with a focal point is that the visual strength and visual impact of a garden depends on making relationships. Making a great garden has to do with setting relationships between the elements of the garden in motion. Setting a focal point in an area of the garden is the seed, root, starting point to set these relationships in motion. It's a focalizing element that stills, calms, and concentrates the attention, bringing the senses into alignment, attunement. Simultaneously, the focal element activates the relationships around it.

In many ways a garden is like an opera with many characters, costumes, songs, scenes, and objects filling up the stage set. Thinking that you are putting on a show frees you to think outside your normal parameters. After you've thought big, then if you want to call each setting a room and bring in stoves, refrigerators, swimming pools, ice makers, plasma screens, hot tubs, and boccie ball courts, go ahead. But for my money, I would never want to start there. I want the star of the show to be a color.

Once you have your basic design with a focal point, you can then address how you want to work with color. I use one color palette for each working space. Some artists refer to their canvas as their working space. With that canvas, you know where you are painting. You have on your palette the colors that you will use on that canvas. Taking time to connect with the working space, feeling into it, making contact with the soul, essence, potential of what the space has to offer can help you decide how to apply color to canvas.

Come sit with me on a bench as we whisper about the soul of a space. Let yourself feel the space, let it be alive, like a live dancing partner. You are creating your own personal, up-close frontal exposure, your own intimate relationship with the space. Gardening is being an artist. That is what it's like when you make a painting or a sculpture— you are creating an intimate, engaged, and thus engaging, relationship.

Clay fashioned into garden art

TRY THIS: Play with Clay and the Kitchen Sink

Buy two bags of clay and manipulate, squeeze, push, pinch, punch, or roll the clay into various garden shapes this area could have.

Take out a large tray or card table. Set it up in front of your working space, taking out the kitchen sink—pots, pans, utensils, dishes—and arrange your garden space by using objects from your house to describe the space. Give yourself time and permission to make intimate contact with the space you are working with. Take notes—do freewriting in your journal to see what comes up. Let the space talk to you.

Purse fountain: a focal feature sure to draw the eye

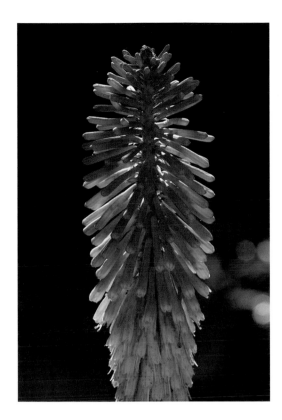

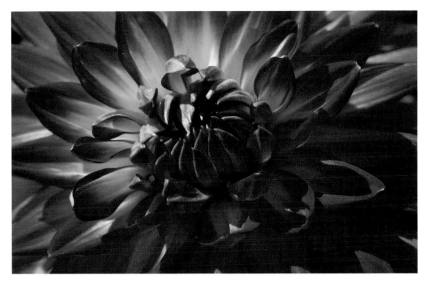

Finding color stars at the nursery—
dahlia, red-hot poker, lily

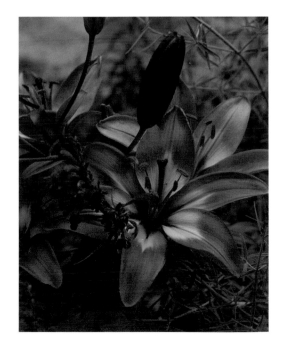

Any artistic medium is worth exploring to increase your connection to the space you are working in your garden.

Focal Feature Possibilities

A focal feature can be anything: a tree, a large shrub, a rock, a bench, a planter, a sculpture, an arch, or a found object. Remember, this focal feature is not just going to stand there. It's going to help you with your seed color and make your garden come alive, blooming with color. I try to use a focal feature that has the seed color and other colors I want to use in an area.

I always follow the path laid out by the song "My Favorite Things." I want all my favorite things around me in my garden. When I work with clients, I ask them what their favorite things are, and what things, images, materials, plants they want around them. One friend collects purses. She showed me her closet where she has row upon row of great purses. We took three, bronzed them, and turned them into fountains. Open your closets—find focal features!

Here are some other places to look for focal features:

🌸 Nurseries—Look at plants. Go through the tree, shrub, rhododendron, exotics sections of nurseries, asking yourself which of these plants would make a good focal feature. Make a list by color or write down your color triangle and select at least one plant that's a star for each color as a focal feature plant.

🌸 Rock yards—Discover a "rock star" for each color point on your triangle.

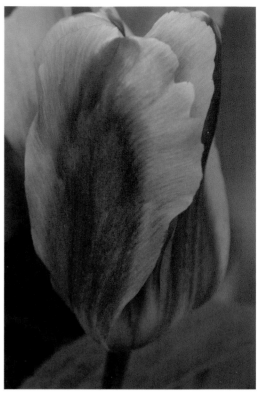

ABOVE AND LEFT Tulip meets planter:
a match made in heaven

Repetition and balance in
a plant-planter combo

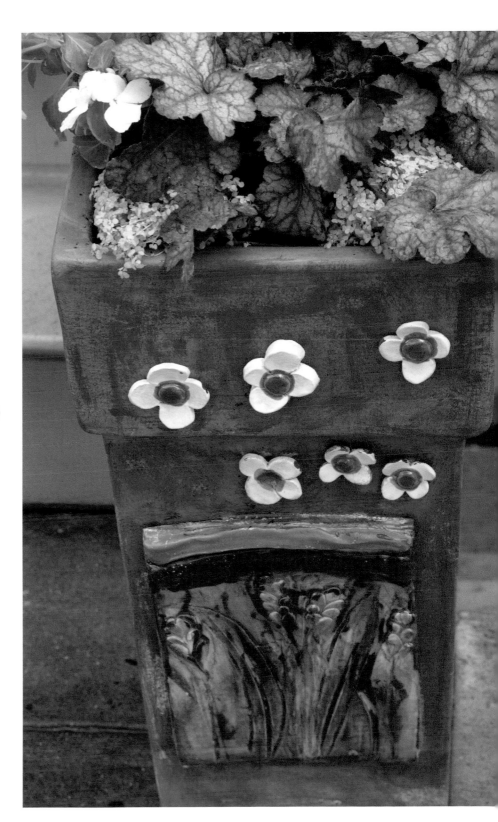

❁ Flea markets—Go to a flea market, check out garage sales, comb salvage yards for focal features.

❁ Art galleries and Web sites—Go to galleries and search the Web for sculpture stars for your garden's focal features.

In my garden, benches, sculptures, and planters carry me through the seasons in two ways. First, they stabilize the garden through all the seasons; the features look good in winter, spring, summer, and fall. In the winter, they are the main feature of the garden; by summer, they are engulfed by foliage. Second, they provide a constant, stable color palette or reference for the plants to play off of year-round. It's worth the effort to bring more focal features into your garden. It's also worthwhile to enhance the existing focal features, which include your house, gates, walls, and pathways. We will revisit your home when we get to the section on paint. Along with a camera, a paintbrush figures large in my gardener's toolbox. Get ready to paint your house!

Planters: Instant Color Gratification

If you like quick results and don't want to be patient for plants to grow, then planters are the ticket for you. Planters make large, colorful, bold statements not just quickly but instantaneously. Planters work to set the colors of a whole area. Use your color palette to first select the planter, then coordinate the planting, also using your color palette.

Most pots I plant are circular in shape. I follow a very simple planting pattern to have color work in the planter. First I divide the circular planting "stage" offered by the container into the front section, the middle section, and the back section. In each section I plant one plant in the center and a plant on either side of it. Each center plant is a separate variety. The two side plants are usually the same variety. I put a low or cascading plant at front center, a medium or tall plant at the center, and a medium or tall plant at back center. If the planter is up against a wall or other high backing, then the last row will have a taller plant than the center middle plant. The side plants are made up of three sets of twins: low, medium, and tall.

This is my basic arrangement for planters. If it is a large planter, I may fill any in-between spaces with very small plants or bulbs. Regarding the color, use your whole color palette between the planter color and the plantings. You can balance the color just by having repetition in the side plant pairs.

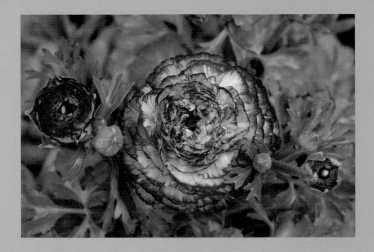

TOP Ranunculus suggesting
a color combination

BELOW Pot painted to match

TRY THIS: Paint Some Pots

Painting pots and then planting them offers instant gratification, has the "Wow!" factor, and gives you a chance to try out color combinations before committing a whole garden space to the colors. A few times a year I hold pot painting workshops in my garden or at a local nursery or show. This is what we do:

❀ Start with clean, dry terracotta pots.

❀ Gather basic painting equipment, which includes various brushes, rags, sponges, and a piece of rubber that you can cut and use to make patterns in the paint. I always use exterior house paint.

❀ Try several methods of applying the paint. They all bring great results. Sponging, smearing on with rags, painting with brushes all work as ways to apply paint to pots.

❀ Make a patterning tool to comb through a layer of wet paint on top of a layer of dry paint by cutting teeth into a piece of rubber. People taking my workshop love this squeegee tool. Paint one coat and let it dry. After you apply the second coat, drag the cut rubber squeegee through the wet paint to make a pattern. Let dry.

❀ I neither prime nor seal my pots, giving the weather a chance to get into the act.

This works for all sizes of pots. Try out one or several of your color palettes. Better yet, paint a pot for every star color point on the color triangle.

Benches to Light On

In the garden, benches are landing spots for people, just as flowers are for bees and butterflies. One time a woman who was flighty as a butterfly flew from my sidewalk into my garden with widening eyes and exclaimed, "Why, there are so many seats to land on and be amazed by the abundance of flowers!" "Yes," I replied, inviting her to light on the newish mosaic bench. "What made you decide to have so many benches?" she asked. "Ferdinand," I replied. "Ferdinand?" "Yes, when I

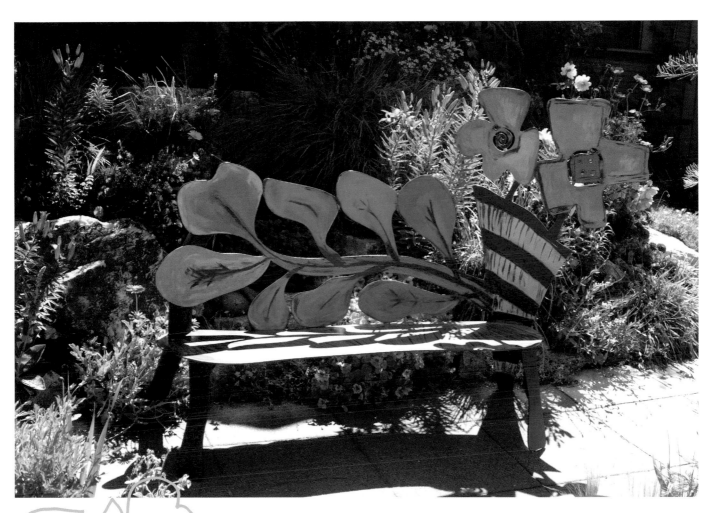

was a child my mother read me bedtime stories every night. The peaceful bull, Ferdinand, who just wanted to be left alone to smell the flowers rather than going into the ring to fight, was one of my favorite stories." "Hmm," the woman nodded, as she got up to try another bench.

Benches are great places for gardeners to rest and tune into the garden, or to sit and chat with friends. I sit on benches to contemplate the colors of the garden. Useful and important design features, benches help you organize the space. Much of design is about organizing space. We all organize space somewhere, so we are familiar and comfortable with that activity in some part of our life. This makes it easier to carry it over into another area of life.

From this perspective, I grew up setting the dinner table. A bench to me is like the dinner plate between the forks on the left and the knives and spoons on the right. In the garden the knives, spoons, and placemat organization is supplanted by a bench in the middle and planters on the left and right. I have an idea. What if you made a bench that looked like a plate, and planters in the shapes of knives and forks? That could work. Don't you think? Then, color the whole thing in. Paint the bench and planters, then match your colors with the plants.

A whimsical, storybook bench is a good thing to have in a garden. I heard on the radio that reading stories and talking about what you've read is very important in the development of children's brains. Well, we all want our children to have brain power. The researcher went on to say that reading to children seeds success as children travel toward adulthood. More than one person has asked me to design a bench from which they could read to their children and grandchildren. This is before I heard about this study. Common gardener's sense to me. My grandmother read to me out in the garden seated on a bench.

One of the gifts of the garden is that there is so much of value to keep reseeding from generation to generation. Benches and reading from benches are garden traditions worth renewing. Making the bench your own by painting it a color that draws you and others to it will give you a story starter.

Sculptures for Stability and Elevation

Would you order a pizza and say, "Hold the cheese"? No. Unless you're dieting, but then you wouldn't order a pizza. You'd order a salad, right? Having a garden without sculpture is to me like pizza without cheese or tomato sauce. It's a BLT without the B, or the L, or the T. It's just not a BLT and doesn't cut the mustard. No excuses. Your garden needs sculpture. I'm a sculptor and a gardener. Trust me, I know.

TRY THIS: Take Yourself on a Sculpture Date

Give yourself permission to fall in love. There is so much to explore, old and new, in the world of sculpture.

❀ Find several local sites to view sculpture. Museums, galleries, and sculpture gardens are the usual places to view sculpture.

❀ Go to another city to view sculpture. I always check out the whereabouts of sculpture when I go to a new city.

❀ Museum stores, libraries, and bookstores are great places to pursue the world of sculpture. Locate the work of at least one artist that moves you. Find a sculptor who works with color as well as form.

❀ Go to an ancient site such as Pompeii in Italy or a historical garden such as Tivoli to view sculpture. You can do these trips in one day. If you can't do this right now, then take a Web journey to these places. There is a big, wide, wonderful world to explore.

❀ Can you believe that with my love of sculpture I have never been to Egypt? Let's take a tour of Egyptian sculpture together. It's on my list. In the meantime, I have spent many an hour being inspired with my nose in books about Egyptian art. Take a date with a book on Egyptian sculpture. Curl up on a garden bench and find that spot in your garden that waves to you. "Here, over here, Dearie, this is the spot for a sculpture." Egyptian art, especially hieroglyphic painting, is done in profile. Design a profile sculpture for your garden.

Dress turned into a sculpture

TRY THIS: Add a Focal Object for Seasonal Color Changes

Focal objects can carry you through seasonal color changes. Locate a space in your garden that you view from a window. Identify another space as you go into or out of your home. In each of these daily home and garden scenes, locate an exact position where you would put a sculpture or other focal feature. Imagine this space with a planter, a bench, a sculpture, or all three. Take a photograph of this space. Plant a stake to mark exactly where you'd put your focal feature. Mark the stake at the desired height of the feature. Cut out images of benches, planters, or sculptures to tape or staple to the stake. Which of these focal features works best? Decide to make the color of the feature the seed color for this space.

By placing a focal feature in a space that you see every day, you're setting the stage for a picture that goes through the seasons. Once you have the feature in place and have decided the seed color for your palette in the area, you can select plants that will have a succession of blooms carrying you through the season. The sculpture will hold the space, even during winter. Snow on sculpture is delightful, as are raindrops. Now make a list of plants that will extend the color of the feature into the space. This is your starting point for making a harmonious color palette for the focal feature.

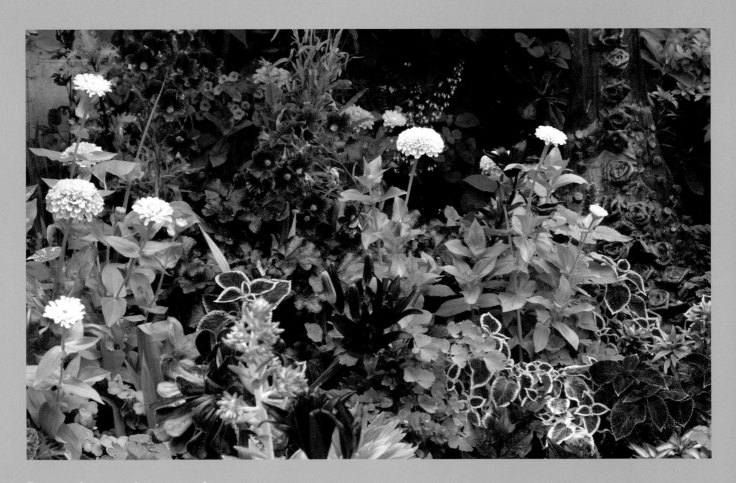

Dress sculpture with summer planting

You don't need sculpture necessarily for color but for elevation. Elevation of feeling. Sculpture can give you the feeling that life is good. That life is meaningful. Purposeful. It can connect you with compassion. With gratitude. Or it can help you show off Attitude like a dancer or a teenager. Make any excuse to get through your excuse. Please don't tell me that cost is what's stopping you. Check the Internet in search of sculptures to tantalize your imagination. There is much available with price tags to fit your budget. If not, then take a class and make a sculpture.

Sculpture makes the garden happen. It brings the garden to life. Especially if you use figurative sculpture, which can add color to your garden through embodying a colorful personality. A sculpture can add an element of surprise. Surprise your audience by making a sculpture a color that sticks out on purpose. Fall in love with sculpture and you might find yourself saying, "Look, Honey, look at what I got today for the garden!"

In my garden there is at least one sculpture made in profile, influenced by Egyptian art. It is a tiny figure carrying a "dream cage fish." The little figure is made of blue-green ocean-colored glass. The glass color provides a color link to a tabletop also made of glass. As your eye travels from the tabletop to the glass figure, you can find the same ocean green in leaves and in glazed planters. Colorful sculpture can help move your eye through a space.

Sculpture can smile at you when the sun doesn't. When water is rationed, a sculpture surrounded by just a few plants can make you happy.

Besides all the big and real reasons, like what would life be like without sculpture to make you happy, there are practical reasons to have sculpture in your garden. Like rocks, sculpture is perfect for organizing and holding a space. Just as important, I often use a color on a sculpture as my starting point, seed, home base, or root color. Taking a color from a sculpture and then extending that color into the garden space, especially at the front and sides of the sculpture, is enticing. Sculptures, at least the ones I know, are not afraid to flirt with flowers. Tree huggers, extend your embrace. Become a sculpture hugger!

I have a bronze dress in the garden subtly painted maroon red. The maroon red of the sculpture has become one of my favorite starting point colors, challenging my imagination to make plant combinations that work throughout the season and from season to season. It was this sculpture color of maroon that introduced me to three plants that

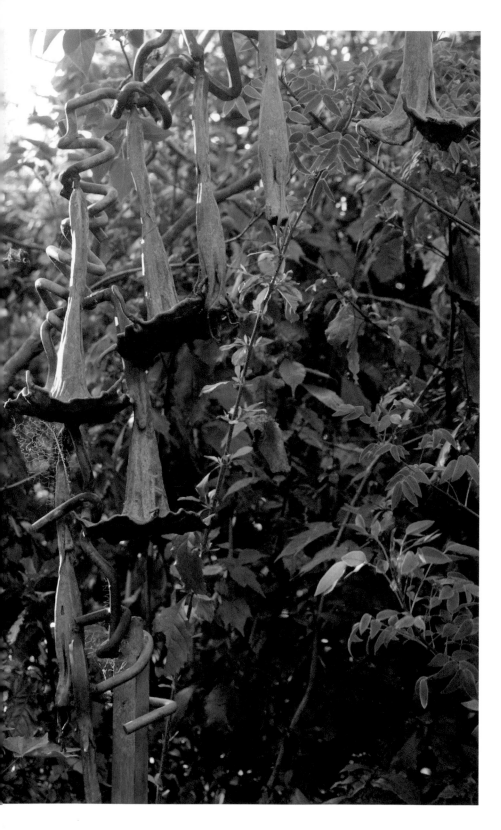

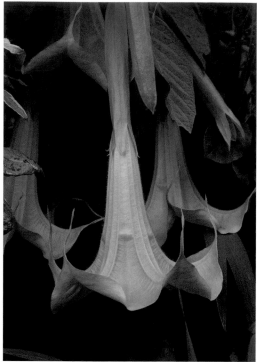

ABOVE AND LEFT An art-ch inspired
by a *Brugmansia* flower

Art-ichoke giving color cues

TRY THIS: Locate a Space in Your Garden for an Arch

Consider where an arch might frame a garden picture for you or mark a passageway from one area to another. Think about how to make the blue of the sky part of the color picture made by the arch.

Art-ch at the entry to a garden zone

completely captivated me: 'Gavota' tulips, 'Honey Bee' tango lilies, and 'Tecolote Café' ranunculas. There is also a coleus with this mustardy yellow–maroon combo. This is one way that sculpture moves you to having an adventure with plants.

Seasons are another reason to plant sculptures in your garden next to plants. Sculpture is there, stable while the colors and clothing of the plants change. Can't you just imagine choreographing several dances between solid, stable sculptures and plants through the seasons? Yes, I will answer for you. Come to my garden or go to my Web site and be inspired.

Now do you agree that we gardeners are lucky that sculpture marries so well to plants? Let's have a wedding for plants and sculpture in the garden.

Art-ches

Looking up, in every sense of the word, is one of the garden's gifts. Leading us toward light, toward inspiration is part of the teachings of the garden. Having an arch overhead helps the garden focus our attention on what is above us and what inspires us. Arches make both useful garden focal points and, more likely, passageways from one area of the garden to another. Like a picture frame, an arch can also provide an ornamental frame to surround a garden space or to see through into another garden.

I wanted more blue in my garden, but all my space was already

Getting help with big rocks—
always a good idea

Airlifting a rock into place

planted. So I added an arch between two garden zones, painted it blue, then planted blue flowers beneath it. It's a small garden zone, but it got me all the blue I wanted because it draws attention upward toward the sky. Now that's an art-ch!

Rock Stars

Construction of the hardscape is one way to set the frame of an area. Defining the boundary is an important step in making a strong, definite color statement. Rock is my preferred hardscape material. Plants are just at home with rock, and rocks are endlessly useful in defining space and creating elevations. I have installed tons and tons and tons of la-dee-dee-da-dee-da rock. Get into the act. Be a rocker in the garden.

Usually there is a local quarry that you can contact about rock. There is much imported material. I know that all our practices are under scrutiny in terms of the effect on the environment, so check it out and do what's right. In my garden I have rocks from various places in the western United States and just over the border in Mexico. Mexican onyx is one of my favorite rocks for its marbled layering of reds, golds, and quartz. I also have turquoise quartz from Idaho and basalt from Washington state.

When setting your stage with rock, look to see if you want to make the rocks the frame, the bookends of the space, or if you want your rock to be a rock star at center stage. You can put a sculpture on top of a rock. Turn a rock into a fountain. Rocks make great stage setters.

Recently I've begun to make more and more raised planters, and I use rocks as supports to connect the walls to. Rocks also make great seats. In the landscape, for example when sculpting a hillside, try using the rock in triangular formations. When you're working on a hill, let gravity be part of the directing hand in placing the rock. Start the rock in one position, then slightly slide it down into place. Cluster a few rocks together once you have your main rock.

The color of the rock is an important element in your color palette for the area. With rock on both sides, you already have the framing colors. You can then tie them together with a stream of colors that includes the rock color. For example, if you have red in the rocks you might use one or two types of red-foliaged plants spaced rhythmically

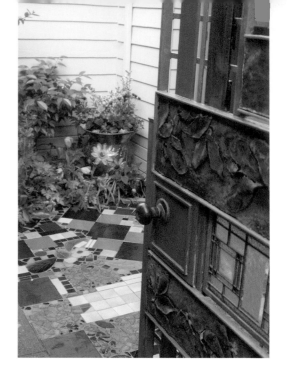

Mix-and-match pavings = color explosion

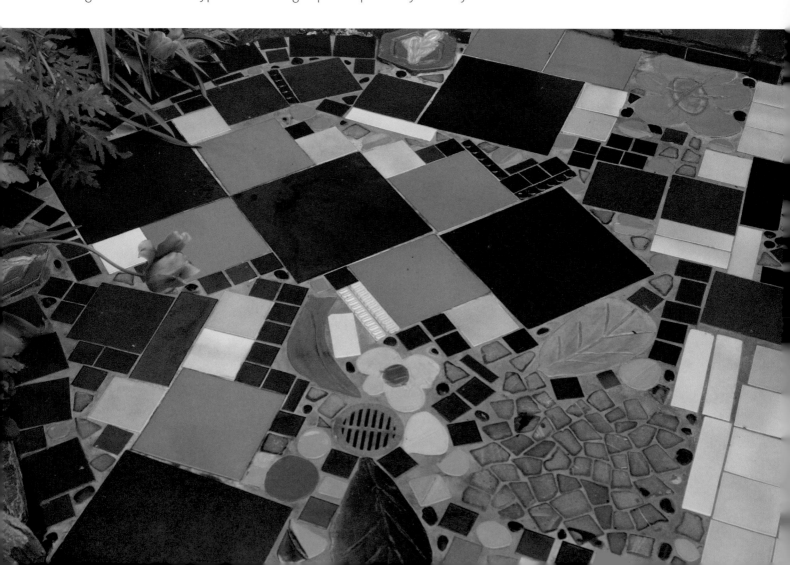

TRY THIS: Make Colored Cement Stepping-Stones

For a stepping-stone, make a form in any shape you want. Watch out—this stepping-stone might expand into a mermaid- or other-shaped patio. Hold the collar of the stepping-stone form in place with short stakes. Close the ends off so that the cement doesn't leak out. I also reinforce stepping-stones with a few pieces of rebar tied together with wire. Drop your rebar into the center of the collar. Next, mix and pour cement. Two inches of cement is plenty to make a strong surface to walk on. Smooth the top.

Leave it plain? I never would. Draw in it, press stuff into it. In two days take off the form, paint, or stain with an iron sulfate solution. Note that painted cement needs repainting every year or two if you want it looking new; or enjoy the weathered patina of faded colors. With stepping-stones I bring the dirt right up to the top edge of the stone, then plant ground covers to fill in.

ABOVE Big stepping-stone made from leftovers

RIGHT Spiral inset in a cement wall

between the rocks. This will provide a definite line of color for the eye to follow. In my garden I extended the orangey red in the rocks throughout the season by planting flowering bulbs and tubers in red-orange shades. The season started with tulips and ended with dahlias. My advice when it comes to rocks: rock out!

Painterly Pavings

A red linoleum square in my Uncle Art's new floor sent me out on a long journey of expanding boundaries in the name of red. First with flowers and paint, then with pavings. I turned onto a path of bringing paintings off the canvas and onto the patio. A big thing when I was in art school was to get the painting off the wall. Get it into the room, get it into the gallery space. I decided to get it into the garden. My Uncle Art's red story is the seed for my getting paintings off the wall and dancing on the patio.

On my parents' stone coffee table in our living room was a large book with the exact same pattern that was now on my Uncle Art's floor. Across the top of the cover—which pictured red squares, yellow squares, black squares, gray squares, white squares, and some lines and rectangles—was the name Mondrian. Did my Uncle Art copy this painting and put it on his floor? The big deal about Uncle Art's

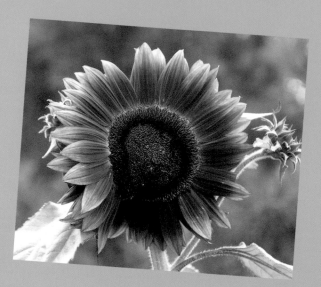

Matching plant colors
to iron-sulfate-stained cement

TRY THIS: Construct
a Cement Wall

You'll need these materials: for the wall forms, wood, or metal flashing that comes in rolls, or corrugated fiberglass that comes in sheets; gloves, wire, wire cutters, nails, screws, electric drill, hammer, stakes, rebar, and concrete.

To make a low cement wall, first draw a shape on the ground. Then construct wall forms from wood or sheet metal (rolls of metal flashing) or corrugated fiberglass. My crew and I use several materials to build the forms. Our trademark is the rippled form that comes from using corrugated fiberglass or metal. We use mostly fiberglass, which we cut with a Sawzall-type electric saw. If you do this, be sure to work with gloves and a mask. String together your form material and stake the walls from the outside. We use wire tied through nail holes to join the pieces, then we use stakes bought from the lumber store and screw the stakes to the wall forms. This makes it so we can easily unscrew the forms after the pour.

For strength and structural integrity, the walls need to have rebar inside, tied together with wire. We hammer the rebar into the ground as far as we can for a secure footing. No matter what you do, cement is prone to cracking.

The cement can be hand mixed from bags in a wheelbarrow or cement mixer, or it can be pumped in from a truck. We do all of the above. Pumped-in cement tends to be smoother, but you have to work more quickly. Finishing the tops of the walls requires a few cement trowels and experience. I like to mush stuff into the tops of the walls. Rocks, round stones, glass, broken ceramics, dishes, seashells, pretty much anything you bring home from a garage sale or flea market can be pushed into a cement wall.

Long cement wall with red pot

Note that during pours, seams of forms sometimes burst. Be prepared by having wire, drills, and hammers ready to make on-the-spot repairs. We also have several five-gallon buckets filled with dirt or rocks to push up against the walls as we pour to stop breaks as well as to shape the walls, giving them that wavy look.

After the pour, wait two days. Remove your forms. Pour on a solution of iron sulfate diluted in water and then gape as the color appears. It's always different. Enjoy the surprise.

Mondrian floor is that when I later became an artist and a gardener, I realized that pathways, walkways, patios, and any space on the ground was fair game for painterly pavings.

A red square was my first stepping-stone into the artistic adventure in the garden of painterly pavings. It was also a step into what I call transposition—taking an object associated with one place or purpose and transposing it into something for an altogether different space or purpose. This is how you can take a picture you see on a postcard and use it as a pattern for paving. Try this, and you will be developing an artistic mind.

Colored Cement

Cement can be colored while wet by adding pigments or embedding colorful stones, tiles, or glass objects. After the pour and removing of the forms, you can stain or paint the cement, or use thin-set mortar to add tile or other objects. Cement is great to work with for these reasons.

I discovered cement in Roger Raiche's garden. He's since moved, but in his hillside garden in the Berkeley hills he'd both stacked broken pieces of concrete and poured concrete in a grottolike hillside setting. What intrigued me the most about his cement work was the dusty buckskin gold color. He told me he'd simply poured on a solution of iron sulfate. So now for most of the cement I pour, I use this same solution. Iron sulfate comes in a box, and you are likely to find it in the fertilizer section of the nursery. It's inexpensive and environmentally friendly. This golden color transformed my garden work as I started to link the golden cement with comparably colored rocks, foliage, and artworks. Thank you, garden artist Roger Raiche.

Try making a garden feature with iron-sulfate-stained cement. Walls, planters, or stepping-stones are good candidates. If you are making walls, most walls require a permit or engineering drawings if more than three feet high. My walls are mostly under three feet. I make wobbly walls. This makes them Gaudiesque. (Antonio Gaudí was a Spanish architect who was partly inspired by the organic shapes he saw in nature. Look him up on the Web or at the library to get inspired. Or, better yet, go to Barcelona in person to see his work.) My garden shows Gaudí's influence in the wavy wall constructions studded with rocks and ceramics.

Fun with Paint

Paint is a source of immediate, strong color. You can make changes quickly and then make more changes just as quickly. One friend went

LEFT Color ideas sketch

CHAIR

so far as to paint her plants. That was a little too far, even for me, and I'm sure for the plants. Take account of what could be painted in your garden environment. Walls, benches, doors, house siding are all potential subjects. One gigantic color change you can often make is to change the color of your house, or the color of the doors or window frames. Your house is often the backdrop to your plantings. I've repainted almost all the walls of my house to connect with the plants.

Several clients of mine have painted garden sheds or studios. This is a way to get a lot of color into your garden. In one garden, after

TRY THIS: Have an Adventure with Paint and a Brush

What color is your front door? Consider all the painted surfaces of your house, including all your doors. Your house is most likely the biggest thing in your garden. Do you want to repaint it, or just a part of it?

If you want to make a painting on a wall or fence to set a color backdrop for your garden, I suggest you research mural making. It's not that hard to project an image onto a wall, outline it with large chalks, then paint it in.

ABOVE Your house: one big color opportunity

LEFT Fearless mural that outdoes even passion flowers

Presto—instant color

changing the color of the window frames, I painted a bench to match.
Painting the bench was followed by playing the matching game, finding
plants to match the coral-salmon paint, bringing the hardscape and
plantscape into one picture along with the house.

I suggested to one client that she repaint a peeling white fence.
Upon returning to her garden, I first noticed that the doors to the
upstairs deck were flung wide open so the plants could enjoy her
husband's rendition of Mozart on the piano. Next I saw that her fence

was singing a wildly imaginative Greek chorus. She didn't just repaint her fence: she painted a painting on her fence with Greek columns and images of Greek gods. I didn't see any Greek goddesses, only the toothy smile on the client's face as she gleamed with goddessy mischief.

I use exterior acrylic paints for all my garden paint projects. In the end you will boast, like me, that you bring a paintbrush into the garden along with a shovel. Painting, together with a painterly style of planting, is one way to put on a real show in the garden.

Sculptural Hardscapes, Painterly Plantings

The physical landscape of the garden is sculptural. Color in the garden is painterly.

Now that we have journeyed up and down the three legs of the color triangle to make selections for color palettes and worked our way through the basics of garden design, we are ready to put these two worlds together. With your color palette in hand, you have the key to approach the design equation of plantscape-hardscape. Because of my art school background, I tend to describe the activity of creating the hardscape as sculptural, and the plantscape—along with coloring the hardscape—as painterly. After you have placed all the elements of your hardscape, you are ready to bring this picture into living color as you place the plants. Always engage the hardscape with as much of your color palette as possible. Then place your plants to work that color.

To summarize the steps to building color gardens: I always work with frames so that all the decisions are being made within a predetermined frame. I call this inside space the working space. Before coloring your garden, you need to set up your working space. This is very much like drawing a line composition for a painting. I organize my garden spaces like stage sets with a strong focal feature. Having a focal feature is very helpful in designing the space, as it divides the space around it, to the back, sides, and front. You have many options on how you extend and engage the colors of the hardscape with the plants to make lively relationships.

FOLLOWING PAGE Painterly plantings in a sculptural hardscape

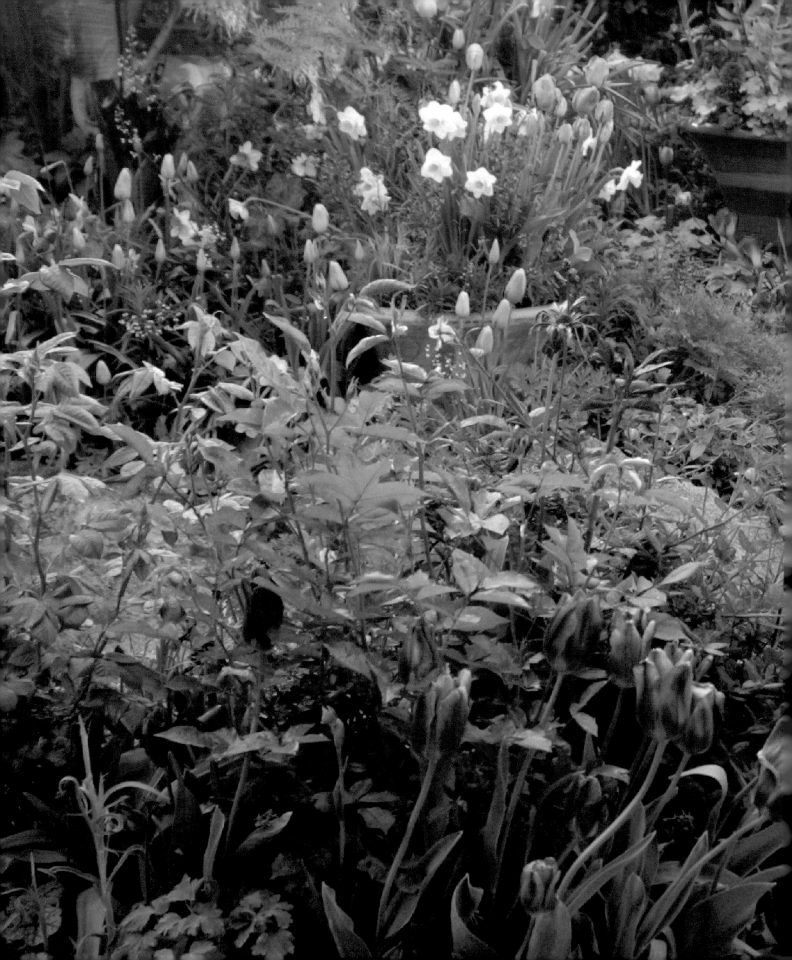

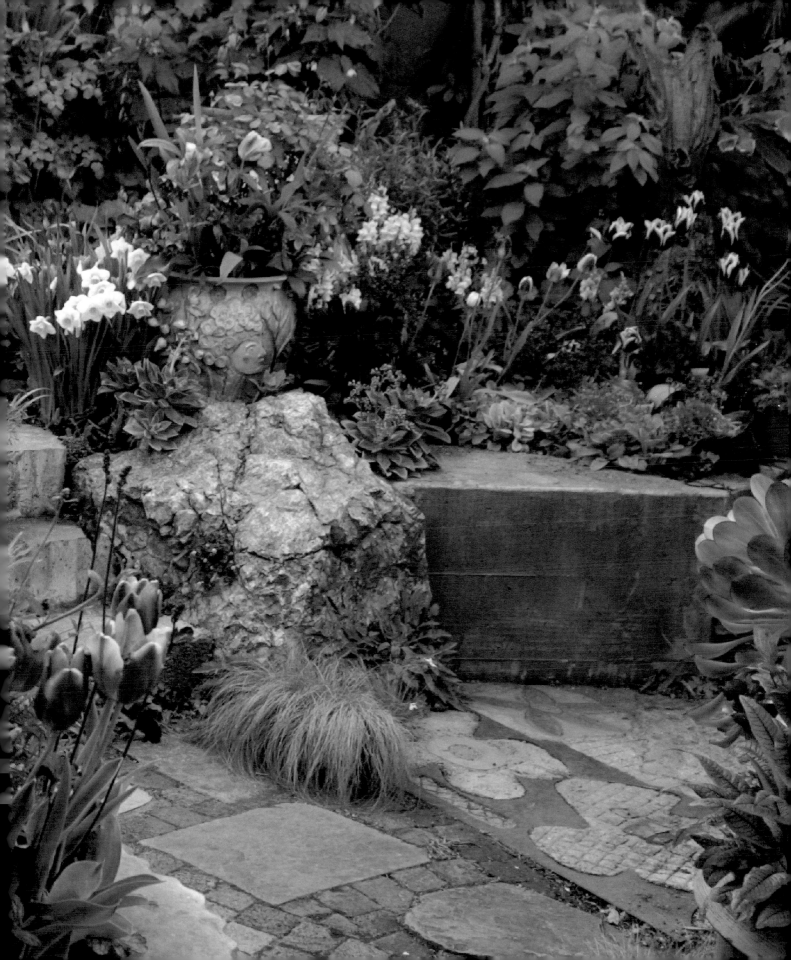

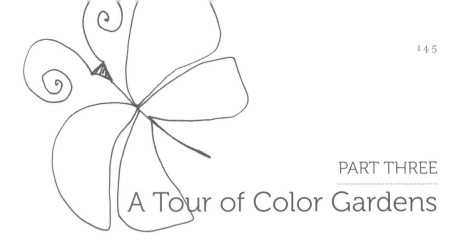

A Tour of Color Gardens

LEFT Orange and yellow flowers singing together

ABOVE My first color garden

To enjoy seeing color at work, we'll now take a tour of some of my clients' gardens, some demonstration gardens, and my home garden.

My First Color Garden

The first color garden I made was based on the personality of a client.

My first color garden was red. When I showed up for a garden consultation at Sandra's house, I was met by a gregarious woman who spoke with lively hand gestures and an expressive voice. Her husband, Sam, reveled in his wife's exuberance. When they unfolded the plan for redoing their cleared back garden, I thought that the division of the space worked but the color was all wrong for Sandra and Sam.

The drawing of the garden as viewed from the upstairs deck divided the space into a lawn area and a patio area surrounded by plantings. The color pink dominated the plant selection without attention to the surrounding colors of the rock, paving, or fences.

"Sandra, that white back fence looks really stark. I think you should paint the fence."

"Okay," Sandra barked, "I'll paint the fence."

"And I wonder about using so many pink flowers. Somehow the color pink doesn't seem to go with who you are. Do you like pink?"

Sandra called out to Sam, who had left the deck for the kitchen. "Sam, Keeyla says I'm not pink, that we shouldn't have pink flowers." Then she turned to me. "Well, what do you think I am?"

I had just met Sandra and having this conversation was becoming challengingly intimate. "I think you're red."

"Sam," Sandra called into the kitchen, "Keeyla says I'm red."

Sam came back on the deck and looked down on the garden. "I think red would be more interesting. I'm excited by the idea of red. What would you use for trees?" he asked.

"Red-leaved Japanese maples," I said.

"Oh! Red maples. I really like those," he responded. "And we can

have red roses. I've always loved roses." Sam was pleased. "Sandra, I like the idea of red. Who would have thought of it . . . a red garden!"

So we decided on a palette of red stone and gravel with abundant plantings of red flowers and foliage, and we placed a red umbrella in the center of the picnic table. On the back fence Sandra painted a wooden fence: painting a fence on a fence!

Focusing on one color when designing and installing a garden can lead you on an adventure with wildly and wonderfully artistic results.

In this case, red fit Sandra's personality, and Sam was in support of both that and one of his favorite plants, Japanese maples. After we put in the garden, Sandra, who had been blocked in her painting for over a year, started painting from flowers she cut in the garden. Sam, as when I met him, accompanies her painting actively at the piano, playing sumptuous music. I made several trellis paintings using the leftovers from the construction of the black-and-white African-inspired trellis. Together Sandra and I had an art show with paintings inspired by her red garden. This was the wonderful effect of turning to red to fire up our creative engines.

Sanctuary Gardens

At the least, my garden is my sanctuary; at the most, my salvation. Being in the garden has taught me a way of life. Planting, watering, and caring for seeds has inspired creativity, joy, health, and abundance. As the Chinese proverb says, if you want to be happy for the whole of your life, plant a garden.

Now come with me to visit sanctuary gardens I have designed that offer serenity through harmonious color combinations and through providing a bench where my client can sit and meditate.

Franny's Sanctuary Garden

When I met Franny she was a tearful woman. She'd put her hands together in prayer position and set out candles with images of blue-cloaked madonnas. Her prayers were heartfelt compassion for the suffering of others, especially children. Her wish was to have a garden where her tears could, metaphorically and poetically, water the plants. She herself was a watery, feeling kind of woman, a counselor to children in troubled times. I knew she had much to offer these families, for her own home was a mix of whimsy, practicality, and compassion: Alice-in-Wonderland-painted hutches, lines of glass treasures emanating light from windowsills, and a practical layout of rooms. The kitchen faced the garden, my favorite orientation for the kitchen.

TRY THIS: Be an Artist

Whether you consider yourself an artist or not, take something from the garden and make an art piece from it. Make a painting, a sculpture, a fountain, a meal, a cupcake decoration, or a pattern to appliqué on a quilt, t-shirt, or pillow. You get the idea—take something from the garden and let it fire up your engines to take a creative step. Did you select something red? I selected a slice of watermelon.

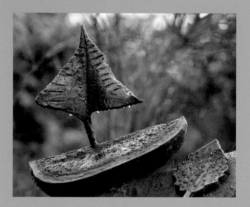

Art arising from a real slice of watermelon

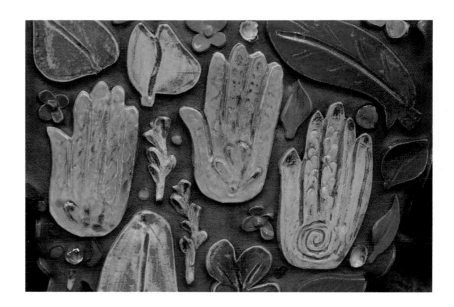

Prayerful, watery, blue

While watery and huggable, Franny was most definite about the how, what, and when of her garden. She wanted it now. She wanted it blue. She wanted it to look like an ancient ruin that had housed a magical mystery sanctuary that you felt as if you'd had the traveler's luck to stumble on. She wanted me to take it from there, and with that she dried her tears and left, calling back, "And I want a bench to sit on to meditate." I guess she expected that this magical dreamer's garden would appear from thin air by the time she got back. Basically, she left me her checkbook with the command to get to work.

I did, and the Moroccan Blue Garden is the result. I took my

Intuitive watery blue pattern

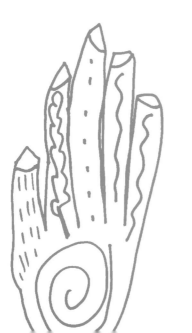

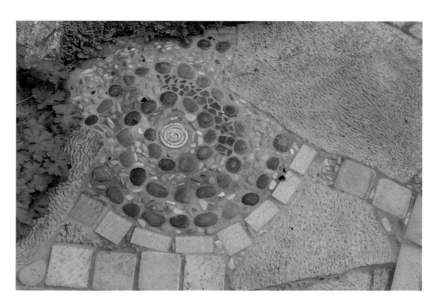

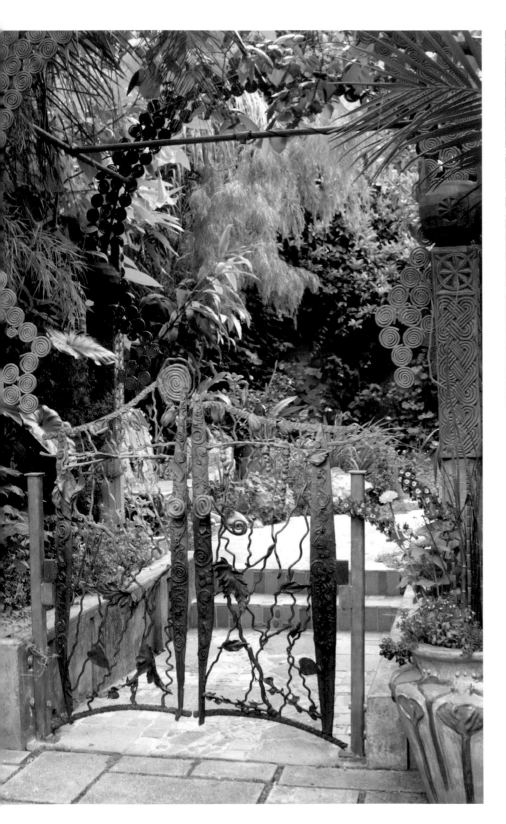

LEFT AND ABOVE Sublimely blue
Moroccan-style arch with garden gate

ABOVE AND BELOW Mermaid patio with
"hidden treasure" hairdo and blue wall

inspiration from a blue wall I'd seen while I was getting my nails done and thumbing through a magazine. That was the motivation I told you about that eventually got me on a plane to Morocco. I was absolutely smitten by this blue. I knew that this would be the answer to Franny's first tearful but commanding design requirement.

The vision of the garden came to me while I was standing on her balcony overlooking the small urban city space. It came to me like a thunderous wave, knocking me down. First I thought of the blue. With that in mind I saw these two great arches. All this from thumbing through a magazine in a nail shop. This was no ordinary blue, but Majorelle blue. It spoke of worlds that I knew nothing about but that had power to them. This color was about something big, something important. I could feel it. Oceans, lakes, rivers. Sky blue jewels.

In Franny's garden, blue is the seed color. There are two harmonious palettes, blue-purples and blue-greens. Blue-greens are at the entry of the garden and anchor the meditation bench. Blue-purples turn the mermaid patio into a shimmering oasis with the "hidden treasure" hairdo on the mermaid. Franny appeared in the garden the day we poured the mermaid in cement with a reed basket piled with treasures collected over many years to smush into the wet cement.

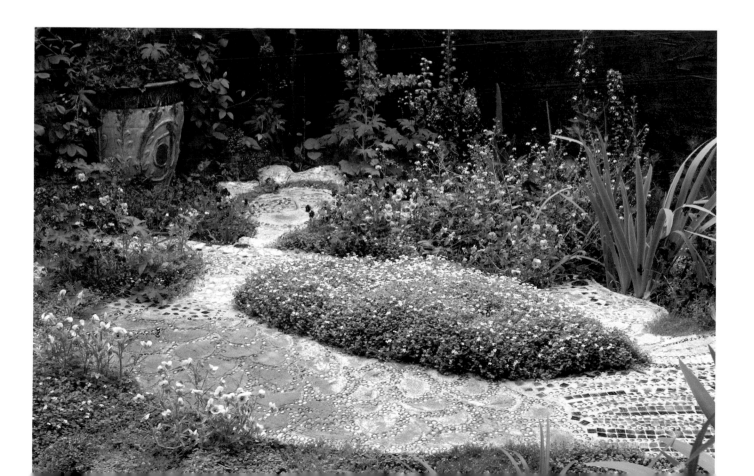

The shade of blue for the replastered wall on the back of the garage was taken from the blue of the wall in the magazine.

Following the making of the garden, it took a few years for me to get my finances together to fly off to Morocco to shake the hands of this blue in person. Thank you, Monsieur Marjorelle, for such a stunning color of blue—a peacock couldn't do it any better.

Sabrina's Meditation Seat

With orchestrating the daily schedule of her immediate family, her large extended family, and a gaggle of animals, including chickens, dogs, cats, and bunnies (the tortoises and fish are her husband's menagerie), Sabrina needed a spot to rejuvenate herself. Like me, Sabrina is highly motivated by color. Pink is her starting point, root, and seed. Pink is *her* color. Pink does it for her. She'd renovated the house from top to bottom, reserving for herself at the back of the garden a well-deserved pink retreat.

The figure, pink of course, is made of glass tile mosaic, modeled after a portrait that I drew of Sabrina. The background garland is made of handmade ceramic flowers and leaves. It all came together by constructing a stone bench and patio below the mosaic, then surrounding the meditation seat and wall with a planting of pink flowers.

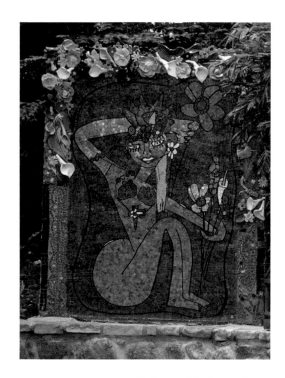

ABOVE AND RIGHT "Sabrina Madonna"
mosaic wall with ceramic flower garland

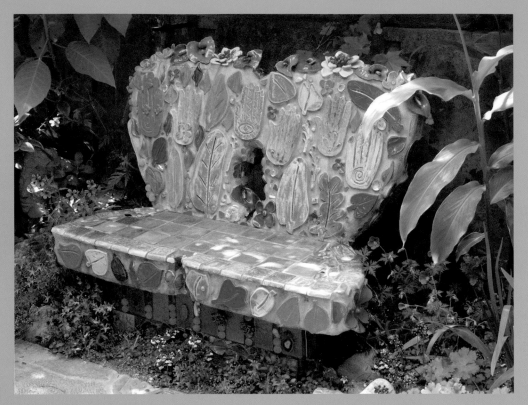

LEFT AND BELOW Tiled meditation seat, starting with a form

TRY THIS: Make a Meditation Seat

Meditation has so many benefits that a meditation seat in the garden is a must. From what I've read, meditation is the key, and for us gardeners, the seed; it's the *open sesame* doorway to just about anything your heart desires on earth. Like a beautiful garden to meditate in, for instance. I know that taking time out from your busy schedule to organize your inner life in meditation is calming.

Once you have a meditation bench, you can discover the meditation practice that is just right for you. There are many books offering different meditation styles. There are also many books talking about colors and how they are related to energy systems of the body, mind, and spirit. My personal approach is one of mix and match, drawing from whatever fits at the time. I enjoy meditating on plants, flowers, just the sounds of the garden, and of course, colors.

Follow the ideas from the section on benches to construct or find a seat. Make a color palette that supports you in taking time to meditate. Select plants that work with both your colors and the light of your selected location. This is a space for you to rejuvenate yourself by cultivating and nurturing your inner garden.

Personal Paradise Gardens

Your idea of a personal paradise might be quite different from mine or from that of my garden- and art-loving friends, Randi and Steve. Let's go over to their house for a visit. Bring your camera; there's a lot to see. Then we'll drop in on Sharon and Ilana to sample what kind of paradise can be created from recycled objects. And we'll check out Sabrina and Ryan's "Let's have a party" fountain.

Randi and Steve's "Take a Chance" Garden

The Hermans titled their marriage "Take a Chance," and it's also the theme of the shady nook off to one side of their garden. Passing beneath a sculptural curtain to enter the garden, if you look up you will see letters beckoning you, too, to take a chance. The garden is set out

ABOVE Paradise calling to you

RIGHT "Take a Chance" garden entry curtain

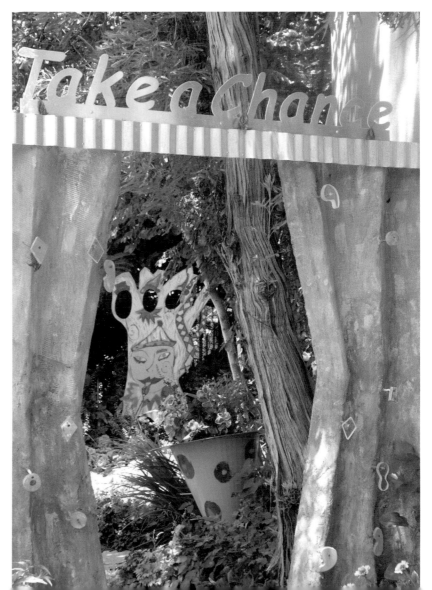

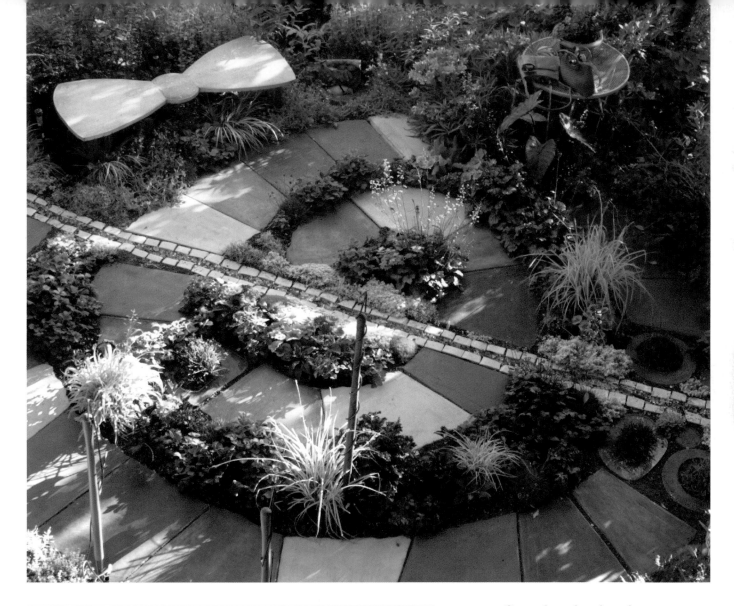

ABOVE Game-board path and
bow-tie bench

LEFT Hardscape–plantscape tango

with games and carnival-like entertainments. First there is a Candyland-colored spiral game-board pathway made of brightly colored cement stepping-stones. Two tall inverted conical "witchy" hat planters bookend the spiral path, while Randi, the ringmaster of this garden nook, might invite you to take a seat on a bow-tie-shaped bench.

This whimsical garden section was hatched by Randi and me to express this couple's fondness for entertaining guests: its motifs are a blend of miniature golf, party game, and carnival. There's a checkered one-hole miniature golf green where the ball rolls from the cup down a hidden tube into a clown's nose. You can stick your face in the carnival clown's head for a picture opportunity. As if we hadn't started enough risky business, shovels are wound with sharpened arrows for a game of popping water balloons tossed from the upstairs deck.

"Take a Chance" is brought together with colorful plantings—red amaryllis matches the clown head's lips and the checks on a snake's

ABOVE LEFT Leo the lion, painted blue

ABOVE Circus in the garden

back; the snake's tongue extends through the garden as glazed pink ceramic blocks. Recycled pieces of long-stemmed wine glasses forming the center of the snake tongue path are a wink to Steve's passion for wine tasting and sharing.

The fountain centerpiece indulges Randi's passion for bold strokes and is a toast to her New York days as a handbag designer. As mentioned earlier, we found purses in her closet, which I then had cast in bronze—complete with cell phone, sunglasses, door-prize tickets, and lipstick. Snakes and hoses spout water from the purses for eye-catching fountain elements.

For a respite from games of chance and things standing on end, a cockeyed brick path leads to a reflective garden of green and white, set off by sculpture featuring granite, copper, and kinetic water wheels. Here, Randi and I sought the restful effects of a waterfall made with white blossoms cascading down a dry creek, set off by sculptures in stable tree-trunk forms, flanked by metal and glass privacy screening. It didn't take too much urging to add one prankish note to the sublime whites: granite spheres from China set upon splintered mirrors reflecting leaves of oakleaf hydrangeas and bits of sky.

As visitors depart via a side-garden stairway, one more sculptural encounter reprises the risky themes of their garden. It's a circus scene in brightly painted metal sculpture on a patterned metal back

door landing. Here our hosts, the Hermans, are celebrated: Steve (a Leo), embodied as a lion; Randi, a daring lion trainer dressed in risqué costume; and a third figure, a mysterious four-armed clown. All are brilliantly framed by the petals and foliage of shade plants in harmonious matching purply magentas and blues, which contrast with lime green.

The Hermans' commitment to making bold gestures in garden design has pushed the envelope and broadened the garden palette, opening possibilities for gardeners everywhere to adventurously combine plants and sculpture. So why not follow their lead and take a chance?

Sharon and Ilana's "Mix and Match" Garden

Sharon found me through my book *Making Gardens Works of Art*. Both she and Ilana wanted an art garden. Because finances were a determining factor, they were intrigued when I offered the idea of recycling leftover materials from jobs and shows, and ceramic blowouts from kiln firing.

After forming the walls and laying out the where and how of the pavings and focal features, I plugged in my remnants from previous projects. Recycling odds and ends offers a challenge as to how to use stuff. This was especially true of the dismantled pieces of wood walls

BELOW Reglazed blue face epoxied to a planter

BELOW RIGHT Artsy patio using recycled materials

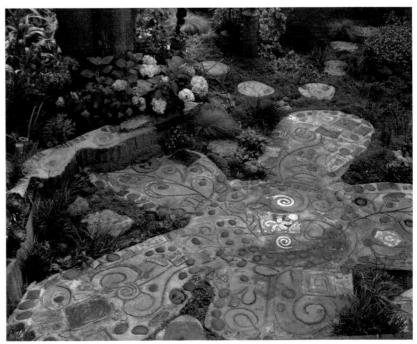

Kissing party between plant and paint

with the blue tile caps. The blue became a theme. We stuck the wood and tile-capped pieces of wall right into the wall forms before pouring the cement. Now the wall remnants have become permanently encased in cement. After removing the forms, I repainted the wood to blend with the rust-colored cement stain.

Some reglazing of old tiles opened up a whole new way to create artsy planters. Among my tile leftovers was a face. To stay with the blue theme set by the blue tile caps, I reglazed the face blue. Instead of sticking the head-shaped tile into one of the wall forms, I epoxied it to a planter. Previously I'd painted planters but not added ceramic pieces. Combining the two opened up new, affordable ways to really bring more color into the garden. This worked so well that we did several more planters in the garden by first gluing ceramic pieces and then painting.

Speckles of white and black abound in the garden details. This came about as a tribute to D'Arcy, the sparky Dalmatian who dashes around the garden. Some tiles were custom designed for the garden. Placed in the center of the patio, a tile of two lovebirds represents the two lovebirds, Sharon and Ilana, who "spawned"—that is, adopted— baby Micah during garden construction. A soft, powdery blue paint meeting the powder-puff head of a blue hydrangea is a kissing party between plant and paint held on the patio.

TRY THIS: Break It in the Kitchen, Paste It in the Garden

Find a place in your garden to add a terracotta pot. If you don't already keep your broken dishes to recycle in the garden, start a basket for collecting broken pottery. Epoxy some pieces of tile to your pot. Use tape to hold the pieces in place until the glue dries. Then paint the pot with harmonious or contrasting colors. Combining recycled materials with paint on pots is now one of my standard treatments to make planters artistic while keeping the cost manageable.

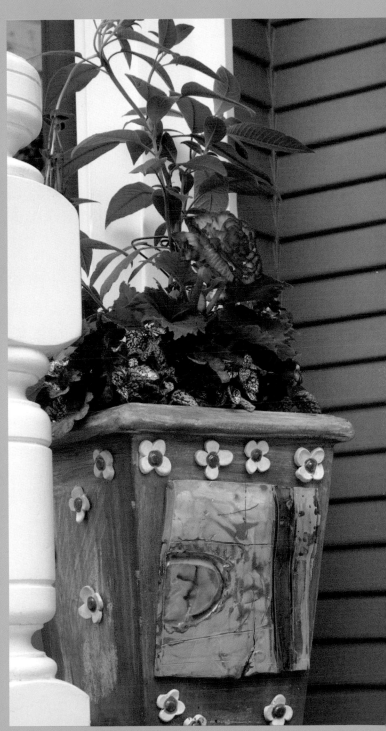

ABOVE AND RIGHT Planters decorated with ceramic pieces and paint

I am a sucker for all forms of garden romance. In my mind, arches—with their skyward gaze—make romantic additions to a garden, regardless of whether one seizes the opportunity to dangle mistletoe on the curves. I'd stockpiled parts of other metal structures behind my garage. By mounting a leftover arch top from this pile on a cement column, we were able to give greater definition to the garden space.

After the garden installation, Sharon and Ilana took me up on a major moving sale of art pieces, including a ceramic series of women eating strawberries. We planted strawberries in the terrace pots so that real strawberries could be eaten next to the ceramic ones, matching reds to reds. A few years later, I returned to do even more planters combining ceramic attachments and paint at the front of the house. This garden evolved in stages and involved the use of recycled materials, encouraging us to be inventive and resourceful with materials and design. People often ask if they can do a garden in stages. I say yes.

Sabrina and Ryan's "Party Couple" Fountain

Sabrina and Ryan work out regularly and have great bodies to show for their effort. Originally the couple portrait of them dancing was to be quite free and quite naked. As I was working on the raw clay for

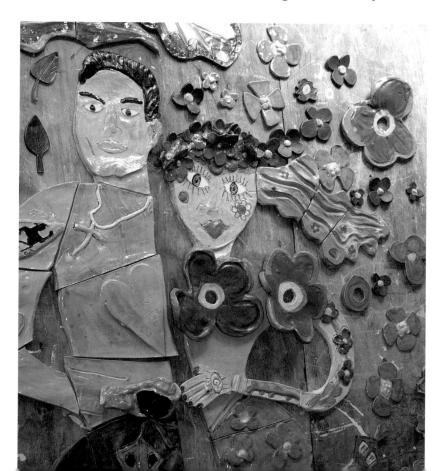

LEFT "Party Couple" fountain

RIGHT Plants in fiesta colors to match the fountain

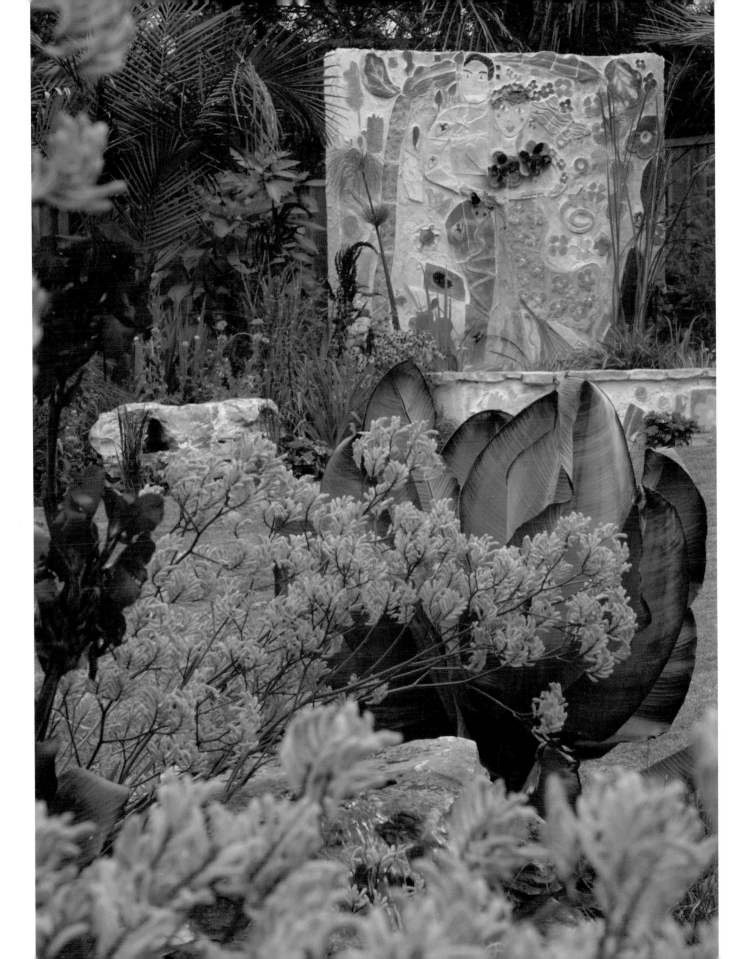

the portrait, having just finished the eating terrace and poolside patio, I said to myself, No way, this is going to be a little too entertaining at family get-togethers! So I got on the phone and called Sabrina: "Sorry, Sabrina, but I don't think so." She agreed. As it turned out, the turquoise and tangerine dress gives the abandoned "Let's have a party" feeling we were looking for and sets the stage for the fiesta colors of the surrounding plants.

By this time you can see that turquoise with orange is one of my favorite color combinations. It works. I use orange as my seed color, with a backup cluster of yellow-oranges or salmon-oranges or both, and contrast it with turquoise. Many succulents have turquoise leaves. Many lavenders, agastache, and other gray-foliage plants have turquoise glints to them. Many ceramic glazes are available in turquoise shades for hardscape features. There's turquoise paint, of course, but nothing beats the turquoise rocks that my rock store claims came out of Idaho.

Fiesta Gardens

A garden party is an invitation to create a fiesta, a feast of color. Everything you eat and everything you eat on or from—your plate, your bowl, the serving platter—like everything in the garden has color. Combining food and dishes is not that different from designing gardens. You're working with the same equation. Instead of plantscape you have foodscape, instead of hardscape you have platescape. The same color principles of harmony and contrast apply. Balancing

Summertime = tomato-ey colors in the garden

Color-combining practice with edibles

harmonious colors between the food and the plate spells "delicious," while contrasting the food and the platter will end in exclamation points and question marks, and will make a great conversation starter. Preparation and presentation of food are always great ways to engage color. The gardens described next are meant to be a feast for your eyes.

Anne and Tim's "Urban Lunch Box" Office Patio

Anne and Tim's garden is laid directly on the remnants of an old asphalt parking lot. Confronted with a barren urban eyesore, I needed a few put-on-my-thinking-cap moments before plunging forward with the idea of just putting the garden on top of it all. Because it was a leased piece of land, we weren't going to tear up the asphalt. I didn't know if this would work. But it did. Several years later it's still standing, with no drainage or watering problems. We built up the planting beds, put down a pond liner for the fountain, and then poured the spiral cement patio in place. You might recognize its shape from the

Hermans' "Take a Chance" garden. This was the practice garden for making the cement forms. Compare the two and you will see how a color treatment makes the two gardens totally different, totally unique.

Out the back door from their office, Anne and Tim often invite family, visitors, and clients to dine in their urban lunch box oasis. Anne wanted the table to be turquoise, so we linked the rest of the color scheme to her turquoise seed color. Paint, rock, glass pavers, turquoise accents on the ceramics and sculpture, along with turquoise-tinged leaves on plants gives turquoise a wide palette to spread its wings over. When Anne and Tim planned a party for this setting, they paired turquoise with orange and salmon shades to bring the party to life. People who come into this setting never guess that the whole thing is plopped on top of a parking lot.

ABOVE Colorful patio on top of a parking lot

RIGHT Playing with food

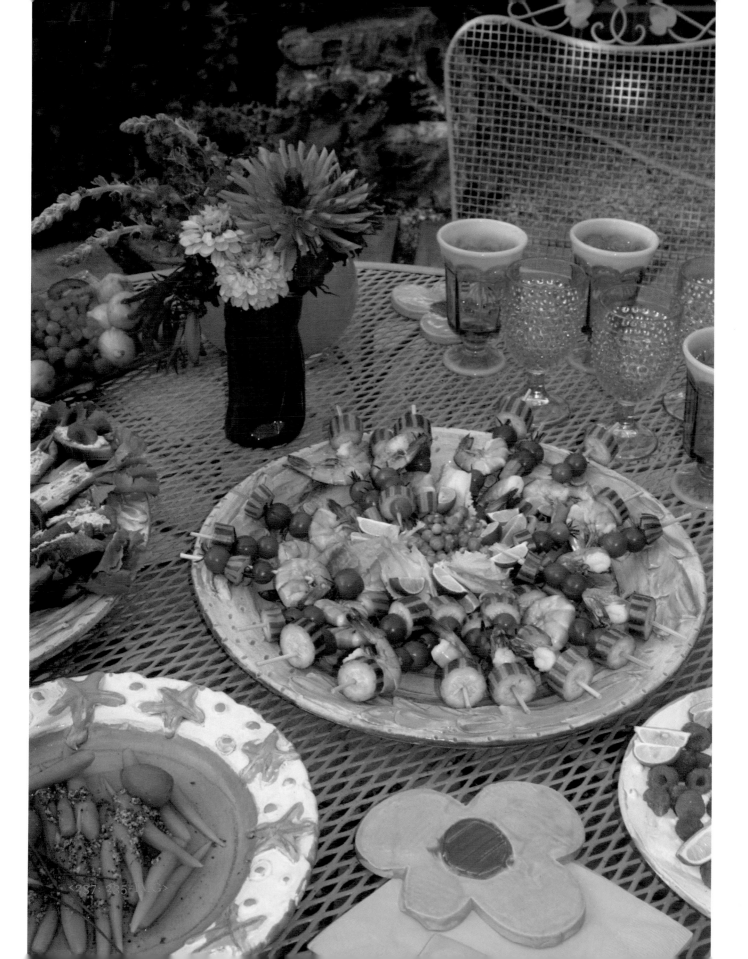

Outdoor Eateries and Edible Gardens

Outdoor kitchens offer immediate association with food gardens. You can link the two areas by using the same hardscape materials—the same rock, tile, planters, and sculpture. Eating terraces and outdoor kitchens are enhanced by adding potted herbs, along with raised beds for vegetables. Just as we lavish so much design attention on our indoor kitchens, outdoor kitchens have sinks, counters, backsplashes, floors, cupboards—all things to think about as you select colors. With an outdoor kitchen it makes sense to blend the décor with the surrounding hardscape of the garden. Pick up the colors of the surrounding plantings with insets of colorful tiles, glass mosaics, or rock details. Planters of mixed herbs and colorful bug-repellent flowers such as marigolds all are natural selections for the outdoor chef's summer garden.

Outdoor eatery surrounded
with veggies and herbs

Glowing 'Bright Lights' chard

TRY THIS: Plant a Color-Themed Vegetable Garden

Organize next season's vegetable garden around a color theme. Planting by color can introduce you to growing vegetables that you've never tried before. Consider the temperature of your vegetable area. Can you use color and materials to warm up or cool down a space to assist in your food production?

Family chef with garden bounty

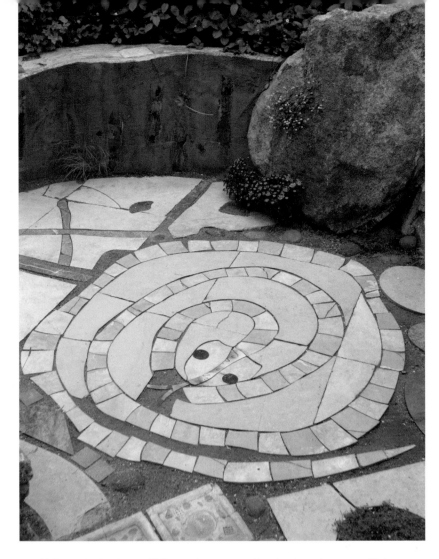

LEFT Giant turquoise pear fountains
RIGHT Spiral snake patio

When designing edible gardens, start by singing the song "My Favorite Things." Sing about your favorite fruits and your favorite vegetables. When teaching children, I love to sing the song "mystical magical food, it's good." There are many loves to choose from in the world of fruits, vegetables, and herbs. Strawberries, pears, tomatoes, and peppers all have showy colors. Use the shapes of vegetables as design guides for your coloring book of garden design shapes. You can color in your strawberries as red, or as I did, link into your imagination and pick another color, such as turquoise. For my two pear sculptures, turquoise adds a note of surprise—saying it's time to rethink your color selection when designing your victory garden of edible plants.

Snake designs have also worked their way into my garden pavings and seem particularly suited to edible gardens. I entered my reptilian phase at seven years of age. We'd moved from the valley flats where tumbleweeds were tossed upward by the wind to be caught on cyclone fences. The winds in our new canyon habitat instead distributed dried leaves, making perfect foils to catch the slithering motion of lizards

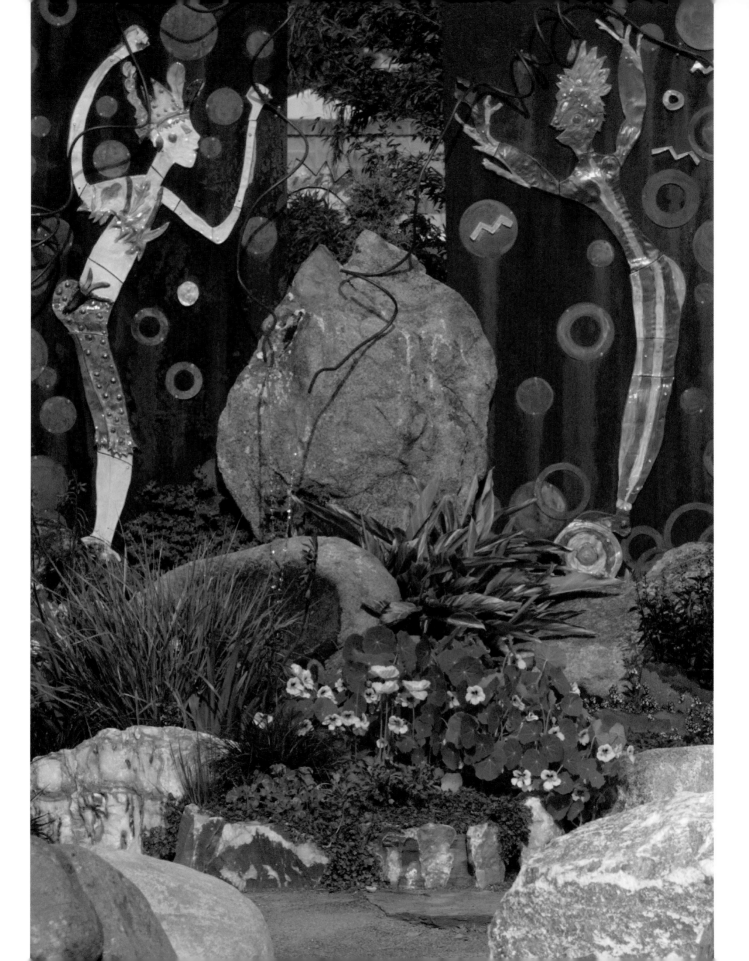

and snakes. I spent hours and hours tracking the pathways of my reptilian playmates, as the canyons housed fewer children than the flat neighborhoods of the valley.

Seated at the table in my edible garden, munching on Eden's fruits, I think of snakes offering pathways of decision and tell friends seated around the table how at seven I picked up a garden snake to show my mom its beautiful stripes, only to hear her scream and faint to the ground as if the snake were offering her forbidden fruits. Animal shapes, colors, and patterns are good starting points for paving designs in gardens edible and otherwise.

"Garden Dancers" Fountain

At a local rock yard, I created a feast of color—a fiesta—around a large boulder. As gardens are so filled with vital life, they invite us to participate, to get up and dance. I think dancing and celebrating the vital energy of the garden is a good resource for sculptural themes. As an homage to my dancing teachers, I created a fountain depicting a gardener along with a dancer. The large boulder stabilizes the ceramic figures as they dance with their hoses. Watering and dancing go together. Ceramics are a great way to get color into the garden. You can always find flowers and foliage to match with the colors of the ceramic glazes to make a colorful rapport.

Keeyla's Secret Garden of Contrasts

For more than thirty years now, the back, darkest area of my garden has been yellow. In 2008, my mom died. As in all the years of our life together, we planted daffodils. As my mom got older, I bought daffodils every year and planted them in her garden when I came down for Thanksgiving. The bushel of daffodils that I divided between her garden and mine were in bloom when she died. To console myself, I took the blooming yellow flowers—our color—waxed them, and put them on a dress, then turned the dress into a bronze sculpture for the garden in homage to my mother. My mother gave me the gifts of becoming a gardener, loving flowers, and loving color. This dress connects me to the joy she felt for life. How yellow is that?! This book is dedicated to her.

I think it's important to give yourself permission to express your feelings about people, love of things, love of life in whatever way you can in your garden. My yellow meditation garden is made up of bold contrasts. I really wanted to set off the yellow. Instead of selecting blue as a contrast, which I've used many times with yellow, I wanted a color

Dancing in the rock yard

LEFT Yellow and purple, an indoor-outdoor love affair

RIGHT Paint and plants in the yellow meditation garden

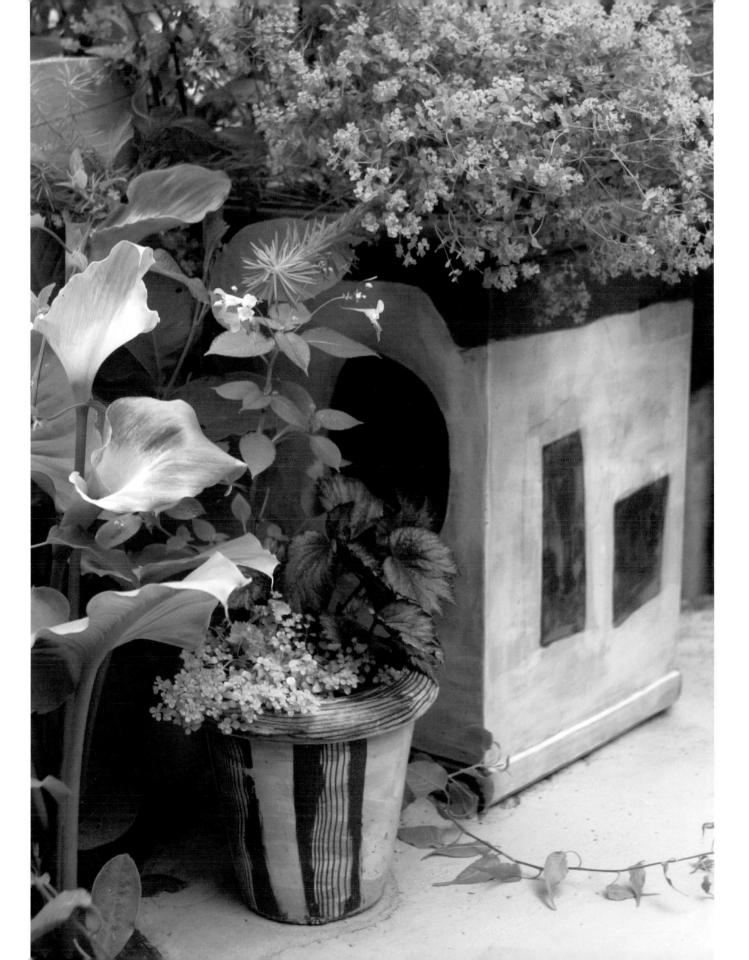

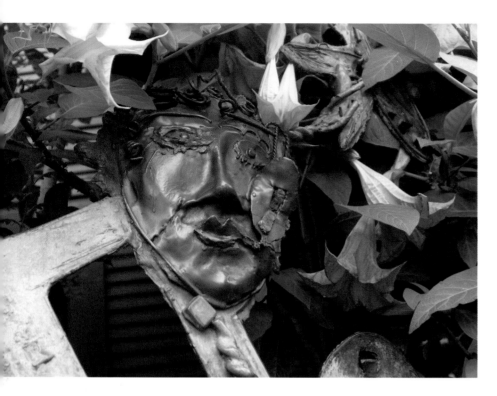

LEFT AND ABOVE Music Girl's sidewalk welcome

that would be more unique, more mysterious, more transcendent. So I chose purple, the color of dreams, the color of surrender, the color of imagination. Purple, I discovered, transforms many foliage plants from ordinary to extraordinary. Be on the lookout for purply hues shading the undersides and highlighting the veins of leaves.

Paint is the main means by which I get the color into the hardscape. All the cement surfaces are painted, as are most of the planters. Some of the planters are glazed. Here and there glazed tiles break up the monotony of so much cement. Matching the plants to these two colors has been fun.

Music Girl, now seated atop a yellow-painted wall in the meditation garden, sings "these are a few of my favorite things." Music Girl can't sit still. She started out as a sidewalk greeter, inviting strollers to come on in. "Step right up, folks. Don't be shy. Come right in. Right here on this modest block is one of the Seven Wonders of Albany. Yes, you there, there is still room inside for you. Step right up, folks, right through the garden gate." For some years the Music Girl sculpture sat in the front garden until house construction removed her from her spot. Then she was carried off to the back garden, where her job is just the opposite. Instead of being a greeter, she is a silencer, whispering cooing tones of "Hush."

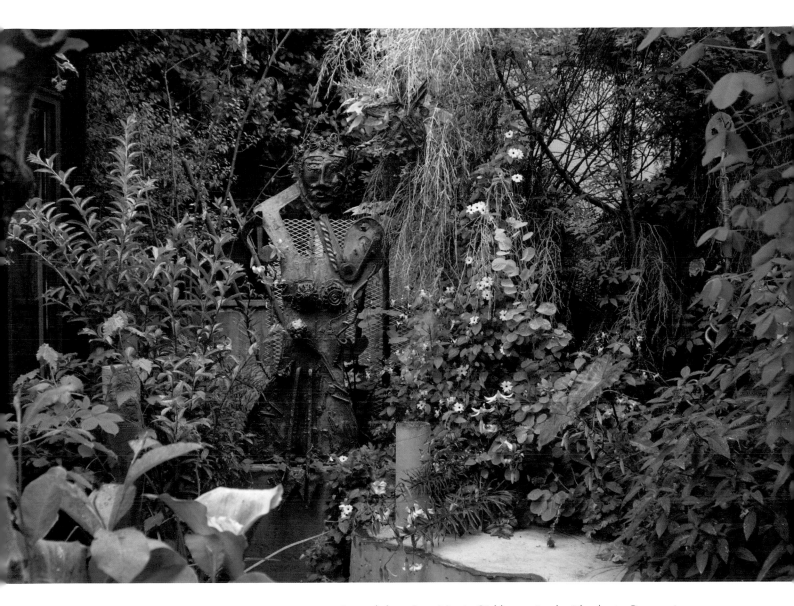

Music Girl in the yellow garden

In each location, Music Girl has paired with plants. Bronze is a neutral color available for almost any pairing. In the front she was paired with salmon colors, a backup palette to the seed color orange. In the rear garden part of the season she hosts yellows, and other times purples, as the color palette is split between the two.

Settled on a wall in the yellow meditation garden, her job now is to call those present to silence, to follow her example of stillness, to listen to the subtle shades of colors and discover how their tones mingle with trickling water fountains.

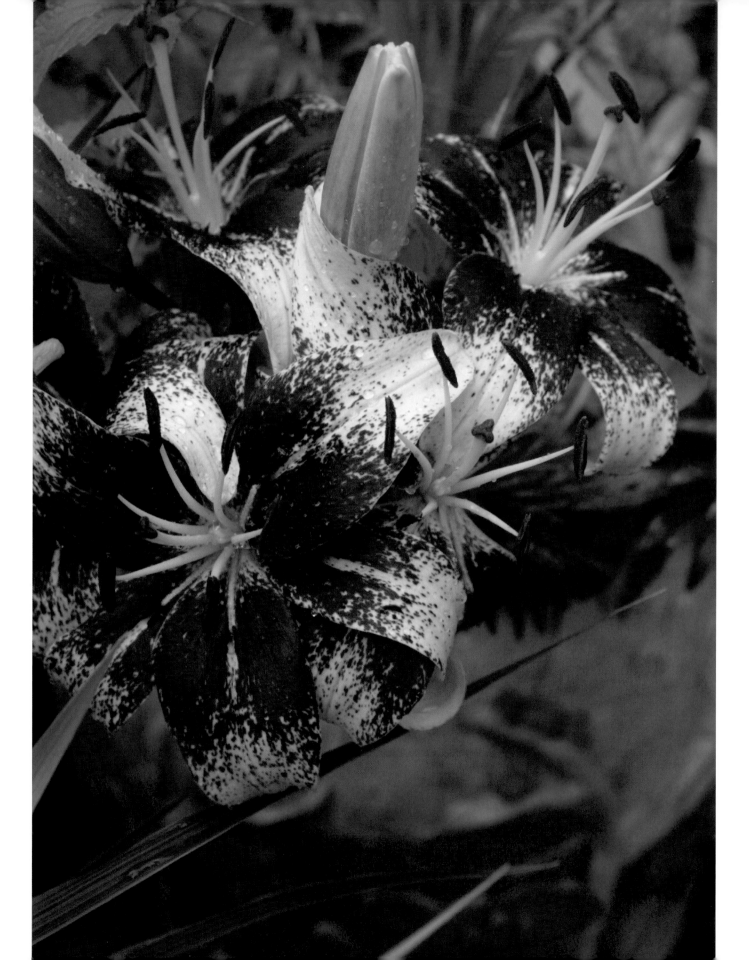

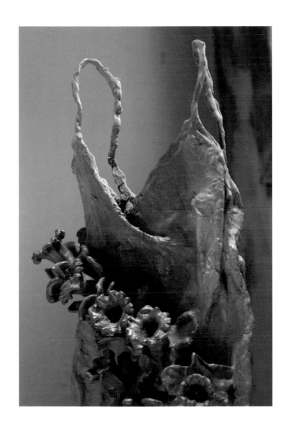

It's been great taking this color journey with you, over the rainbow. Now that you have click-click-clicked your ruby red shoes and are back at home, I hope you will put these tips and color seeds to work in your garden. Be bold. Be fearless. Be happy. Have fun! Color is an adventure. Go for it! Let color bloom daily inside your garden and garden meditations, deepening your connection to the paradise that earth is.

You are always invited to come visit my work with color in the garden online at keeylameadows.net, at my home garden, as well as in my demonstration gardens. My wish is that you are inspired by my work with color and that you will find ways to have color bring you the depth of pleasure that it has brought me.

Happy color gardening!

ABOVE Dress sculpture honoring my mother, yellow, and daffodils

LEFT Always one more flower giving permission

INDEX